To Ray,

A lover of History!

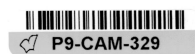
IMAGES
of America

AROUND
SHREWSBURY

Best Wishes!

Bob Ketenheim
10-14-04

BUTTERFLIES

"Greetings From Shrewsbury, Pa.," the young lady says as she admires the butterflies in a field not unlike those found in southern York County. This 100-year-old postcard is printed in color on heavy cardstock. The greeting appears to have been added by a rubber stamp and inkpad, a convenient way for the traveling salesman to market the card in different towns.

IMAGES
of America

AROUND
SHREWSBURY

Bob Ketenheim

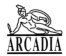

ARCADIA

Copyright © 2004 by Bob Ketenheim
ISBN 0-7385-3632-6

First published 2004

Published by Arcadia Publishing,
Charleston SC, Chicago IL, Portsmouth NH, San Francisco CA

Printed in Great Britain

Library of Congress Catalog Card Number: 2004105913

For all general information, contact Arcadia Publishing:
Telephone 843-853-2070
Fax 843-853-0044
E-mail sales@arcadiapublishing.com
For customer service and orders:
Toll-free 1-888-313-2665

Visit us on the Internet at www.arcadiapublishing.com

To Patti, Erin, and Katie

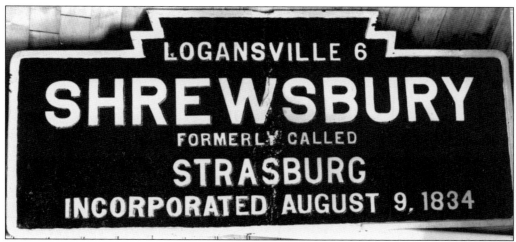

This old sign was one of many erected by the commonwealth of Pennsylvania along major roads on the borders of cities and boroughs. They were made of cast iron and painted in the state colors of blue and gold. This particular sign now rests in the Shrewsbury Borough Building. How it was broken and subsequently repaired is unknown. Note the spelling of Strasburg; other sources show it as Strassburg, Strausburg, and Straussburg.

CONTENTS

ACKNOWLEDGMENTS

A project of this type is never the result of just one person's effort. In this case, it is the result of dozens. I am grateful to the following people who unselfishly shared their documents, memories, photographs, and time: Will and Maureen Abbott, John Albrecht, Phil Attig, Sharon Baker, Linda Bell, Martha Bennett, Hazel Bertholdt, Cindy Bosley, Mary Cooper, John and Brenda Coulter, Carville "Peck" Foster, Chris and Leah Geary, Faye Hall, Verna Hescox, Bob and Jean Hittie, Eleanor Kosko, Kathy Lore, Larry Malone, Vera McCullough, Dan and Sue Pearce, Pete and Debbie Pellissier, Charles Rehmeyer, Jim Richardson, Katrina Sandbek, Steve and Marie Saubel, Jill Sechrist, Harold Shaffer, Ron and Emily Silbaugh, Danny Smith, Dorie Smith, Melissa Stewart, Jack and Betty Thompson, Harold and Sherrill Trimpey, Lyrian Trout, Harry and Bernice Wagner, Rev. William Walker, Larry White, Harry Wolf, Thelma Wolf, and Ken and Trudy Zampier.

I wish to acknowledge my wife, Patti, and our daughters Erin and Katie for their encouragement, their support, and especially their patience.

A very special thank-you goes to Sr. Anne Frances Pulling of Mount Aloysius College in Cresson, Pennsylvania.

INTRODUCTION

The intent of this book is not to tell the history of Shrewsbury and the surrounding area. The intent is merely to show how certain areas and certain things used to look. Anyone interested in the history of Shrewsbury should refer to Dennis Seitz's outstanding work entitled *Shrewsbury: A Blossoming Community* and Jim Richardson's excellent book *Shrewsbury, Pennsylvania, 1834–1984.* Both of these publications can be found in the Southern York County Library in Shrewsbury.

Shrewsbury Township was one of the first Pennsylvania settlements west of the Susquehanna River. It was established by an act of the Pennsylvania General Assembly in 1739. The township originally included all the area containing Hopewell, Shrewsbury, and Springfield Townships. The Potocas Trail, formerly a Native American trail, was the major north–south transportation route linking York and the ports of Joppa and Potapsco on the Chesapeake Bay. The early English and Scotch-Irish settlers that gathered in the area named the village New Shrewsbury.

By the late 1700s, the Potocas Trail had become Joppa Road. Baltzer Faust, realizing the importance of Joppa Road, purchased a tract of land along the road from Benjamin Brenneman in 1797. Faust broke up the land into lots measuring 66 by 264 feet. When selling them, he stipulated that they must have a house built on them, ready to dwell in, within three years or the property reverted back to Faust. The predominantly German settlers who bought the lots renamed the village Strassburg, roughly meaning "village by the road."

Strassburg's strategic location on a major transportation route benefitted its early commercial development. The first business established in the town was on the northwest corner of the crossroads now known as the Square. On that corner, a merchant named Kline opened a store in 1800. There has been a commercial enterprise of one sort or another on that corner ever since.

Other businesses began to spring up in town. Soon, churches and schools were built. In 1810, Joppa Road became the Baltimore-York Turnpike. Because York merchants found it more economical to use the port of Baltimore rather than Philadelphia, all north–south commercial traffic on the road went through the center of Strassburg. Strassburg began to prosper.

In 1821, a local militia called the Strassburg Blues was formed from the ranks of local residents. Later disbanding and then reorganizing as the Jackson Greys, the group existed as late as 1844. It was called upon to assist in quelling riots in Philadelphia. The outfit had only marched as far as the Susquehanna River when told that the riots had ceased.

In 1830, the population of the town and surrounding area was again predominantly English. The name of the town was changed from Strassburg to Shrewsbury. Four years later, on August 9, 1834, Shrewsbury was incorporated as a borough by an act of the General Assembly. The town measured about a mile long and a half-mile wide. It was divided into two political wards, North and South, giving the town two votes in county politics.

By 1835, the North Central Railroad had opened its rail link between Baltimore and York. The railroad had to bypass Shrewsbury because the town's elevation was not suitable for train operation. The line, like other railroads, had followed a local streambed to obtain a negotiable grade. The railroad established a stop about a mile west of Shrewsbury, and the depot there was given the name Shrewsbury Station. As the area around the rail stop began to develop, it began to compete with Shrewsbury. In 1871, the area incorporated into Railroad Borough. The name Railroad was chosen because people in Shrewsbury referred to a trip to the train station as "goin' down to the railroad."

Shrewsbury continued to prosper through the late 1800s. The size of the town remained the same, but the businesses increased several fold. Small sewing, furniture, and cigar factories, carriage works, dry goods stores, and hotels now lined the streets. The business boom lasted until the Great Depression. Many of the small businesses did not survive that period of economic and financial chaos.

The boundaries of Shrewsbury remained the same from 1834 until 1961. In 1961, the borough annexed from the township about 73 acres to the northeast. In 1965, Shrewsbury annexed the 200 acres of the small village of Hungerford to the south. The annexations continued into the mid-1970s, until the borough grew to its current size.

Shrewsbury celebrated its sesquicentennial (150th year) in August 1984. The town commemorated the event with a week of festive activities. Another notable event in 1984 was Shrewsbury's Historic District being entered on the National Register of Historic Places by the U.S. Department of the Interior. This status will help ensure that the town's historical significance and its original architecture will be preserved.

The reasonable land prices, low tax rates, easy access to other cities via the interstate system, and progressive school system of the Shrewsbury area have resulted in a population and commercial explosion. Today, the streets of the borough contain many antique and period shops. Shrewsbury again prospers as the commercial retail center of southern York County.

One
CENTER SQUARE

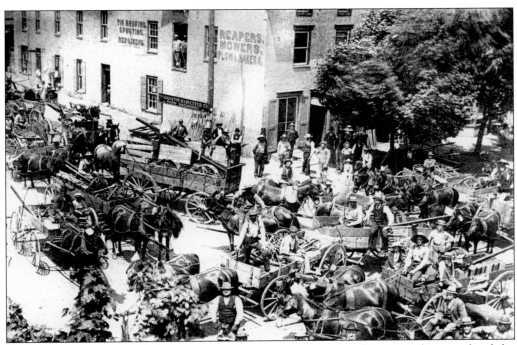

Shrewsbury's importance as a commercial center is evident in this 1902 photograph of the Square. Note that nearly every wagon is carrying at least one wheel in its bed. The sign attached to the pole on the corner reads, "Johnson Harvester Co., Farm Machinery." Few women appear in this image, and those that do are in the background, a true sign of a different age.

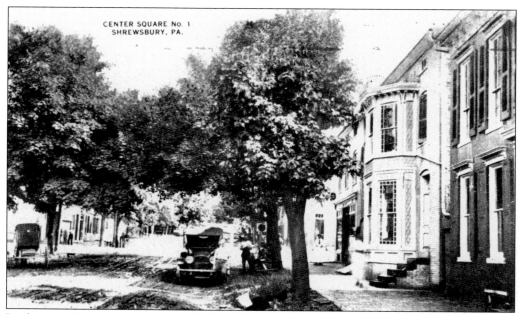

Looking south toward the Square, this postcard view was taken from the front of 14 North Main Street. Main Street still had not been paved, but brick sidewalks had been installed. The side doorway at Gerry's Drug Store, where a person is standing, no longer exists. The white post in the distance, just to the right of the automobile, is a public water pump located in front of the drugstore.

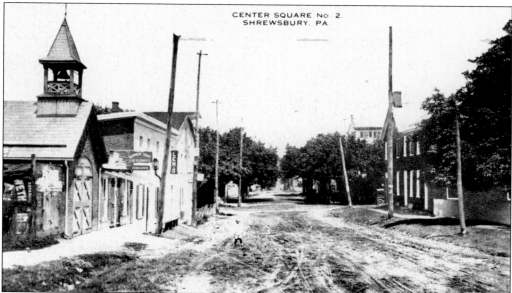

This undated postcard view of Forrest Avenue looks east across Main Street. On the near left is the old firehouse, built in 1880. Beside the firehouse is the barbershop of C. W. Sechrist, with an unfinished awning over the sidewalk. The Shrewsbury Hotel appears on the far right, on the southeast corner of the Square. A young boy stands amidst a mixture of wagon and automobile tracks.

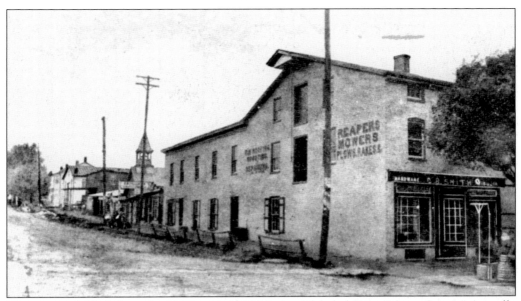

This postcard, likely from the 1890s or early 1900s, is mislabeled, "East Forrest Street." Actually depicting West Forrest Avenue, it shows H. M. Fullerton's cigar and tobacco store at 9 West Forrest. Beside Fullerton's is the old firehouse, and beyond the firehouse is Grove and Bortner's carriage works, located on the corner of West Forrest and North Sunset. Most of the buildings shown here are still standing.

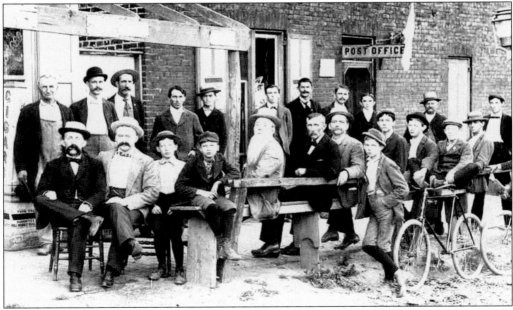

Local community experts gather in front of H. M. Fullerton's to solve all of the world's problems! In the background is the entrance to the post office, at 7 West Forrest Avenue. James Venus moved the post office into his store here in 1889, when he became postmaster. It stayed at the same location until 1952, when it moved into a newly constructed building on West Railroad Avenue.

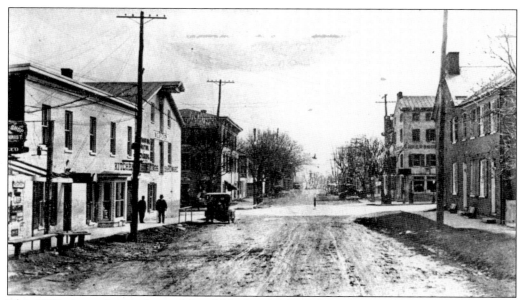

This 1917 view, taken in front of the old firehouse, shows fewer trees and more utility poles and automobiles. The hardware store on the left is marked, "M. E. Bricker." The town post office was located in the back of that building (the old James Venus store). A traffic-control device stands in the middle of the intersection of Main and Forrest.

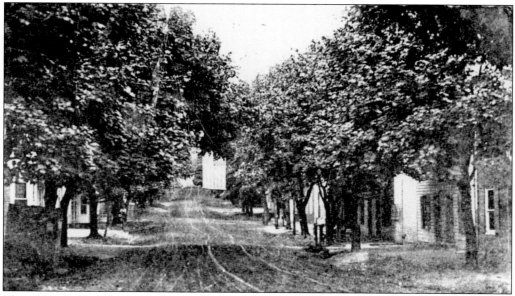

This early-1900s view looks north on North Main Street from the Square. Note the light-colored structure on the right, with the downspout and sign on its corner; the Farmer's Hotel stood on that site until it was destroyed by fire in 1912. The general store of A. J. Kreeger operated from the property after the hotel had been replaced by the current structure. In the 1980s, Paula Trimpey operated her Village Bridal Shop there. The narrow roadway on this side of the building is Kreeger Avenue.

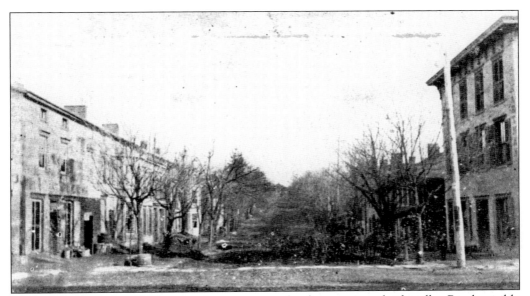

Looking north in this 1907 postcard, one can see the dirt streets and sidewalks. Barely visible in front of the Jackson House is one of the many horse-drawn wagons that were used to transport goods in and out of town. Note the large bulb in the street lamp, lighting the intersection of Main and Forrest.

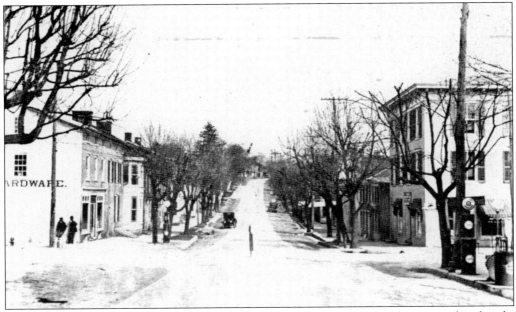

This 1917 view looks north on Main Street. By this time, the street had been paved and curbs had been installed. Interestingly, gasoline and kerosene pumps and oil drums sit in front of the M. E. Bricker building on the left and the Shrewsbury Hotel, just out of view on the right. The gas pumps at both locations are marked, "Atlantic Gasoline."

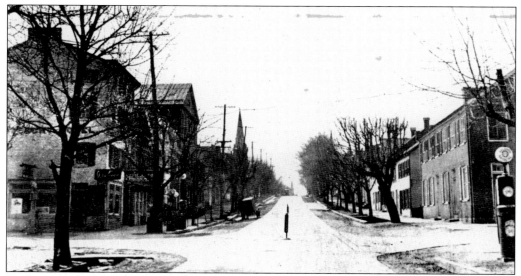

Looking south across the Square, this undated view reveals a paved Main Street and Forrest Avenue. The ground floor of the Shrewsbury Hotel now has larger windows and a side door. The large building beyond the hotel is the 1850s Odd Fellows Hall. The M. E. Bricker building stands on the right, serving various owners as a dry goods and hardware establishment. Today it is an antique shop. At the first building on the right, the Gerry family, over three generations, has operated medical practices and a drugstore.

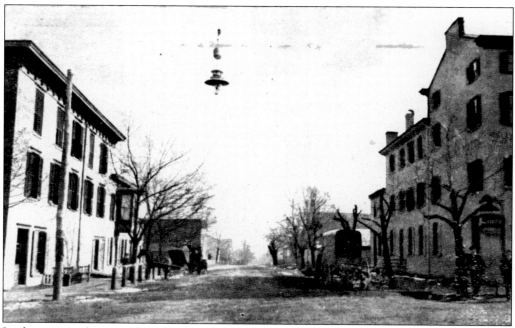

In this eastward view of East Forrest, the Jackson House (left) stands on the northeast corner of the Square. Built *c.* 1869, it was razed in 1974 to allow for a new bank building. The Shrewsbury Hotel (right) stood on the southwest corner of the Square until it was removed in 1960 for a garage and gas station. In the distant right is the hotel stable.

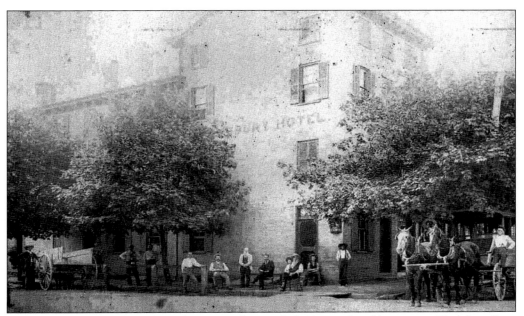

Built in the 1800s, the Shrewsbury Hotel provided 20 comfortable rooms. The first floor consisted of a dining room, a barroom, a reading room, and a samples room, where traveling businessmen could display their wares. Several other hotels operated in town at this time, but none offered accommodations of such quality.

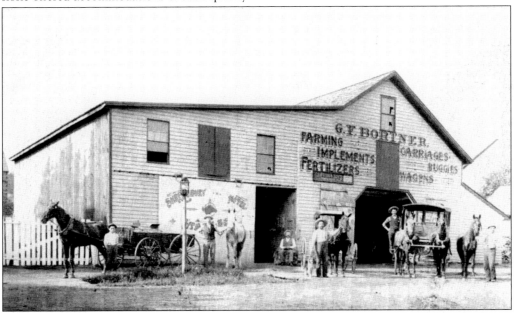

When George Bortner owned the Shrewsbury Hotel in the 1890s, he also operated a livery stable behind the hotel. The stable was along the south side of East Forrest Avenue, on the lot that is now occupied by the fuel pumps of Choice Discount Cigarettes. The sliding door on the left announces the "Shrewsbury Hotel Stables." This location later became the site of a garage and several gas stations.

15

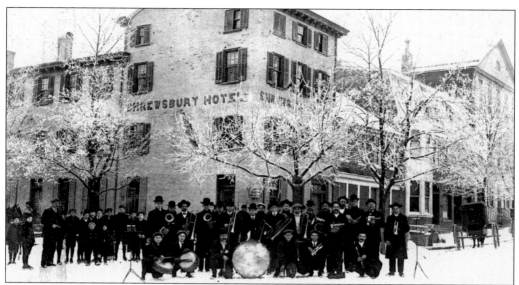

Many bands throughout the years would march the streets of Shrewsbury playing Christmas music. The small sign on the corner of the hotel is a beer advertisement indicating that the town had not yet gone "dry." The tall building on the right is the Odd Fellows Hall. Over the years, the three buildings between the hotel and the hall housed numerous small stores, including Norris', Johnson's, Attig's Meat, Harbold's Meats, and Lida's (Thompson) Fabric Store. A small glove factory once operated at the back of 5–7 South Main Street.

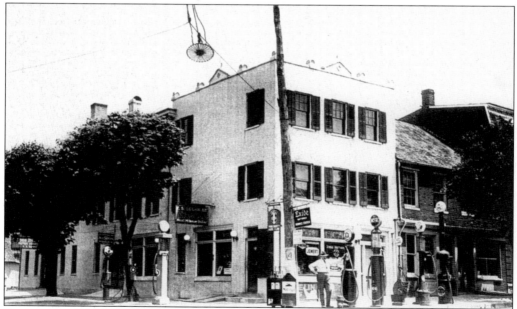

By the time this photograph was taken in the 1930s, the Shrewsbury Hotel had been modified to a three-story structure with a new roof. The building now had a stucco façade with embedded pieces of glass in the finish. Frank Sechrist converted the hotel into a car dealership and auto repair facility on the first floor, and apartments above. The building to the right of the hotel still stands and is the first building facing Main Street on the southeast corner of the Square.

On the south side of East Forrest Avenue, at the rear of the Jackson House, was Shaffer's Radio Service. Melvin Shaffer opened the business there in 1934 and later moved it to 39 South Main Street. The Coca-Cola sign at the end of the block hangs on the southwest corner of the Jackson House. The young boy is Harold Shaffer, present owner of Shaffer's Sales and Service on Plank Road.

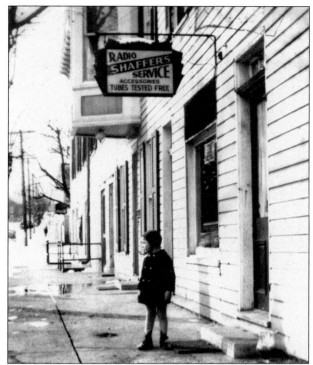

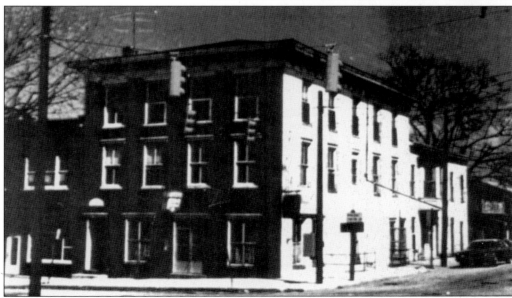

This early-1970s photograph of the Jackson House was taken shortly before it was razed for the construction of the York Federal Savings and Loan building. Constructed c. 1869, over the years the Jackson House held apartments, a general store, a clothing store, medical offices, a pool hall, a bus station, and restaurants operated by Charlie Wagner and later Earl Helfrich. In the late 1920s, owner Frank Sechrist built a movie theater on the lot on the north side of the building.

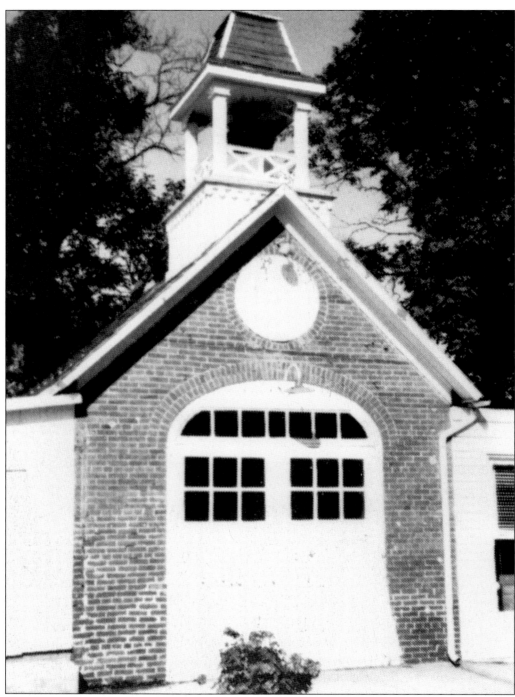

This firehouse was built in 1880, after the previous station had been destroyed by fire. A hole had to be cut in the back wall of the building to accommodate the long ladder carried by the town's hand pumper. Through the years, the station became an icon of the community, and its image was used in the logo for Shrewsbury's sesquicentennial in 1984.

Two

NORTH OF THE SQUARE

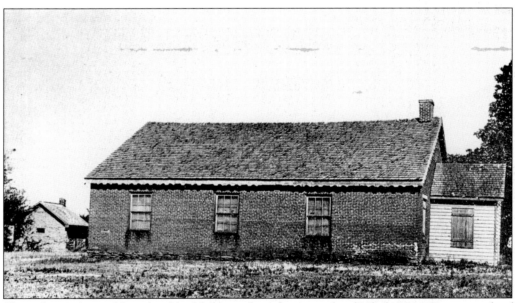

Shrewsbury's first public school building stood on the east side of North Main Street, south of East Clearview Avenue. Classes were conducted here until a new school was built in 1887 on West Railroad Avenue. After the school had moved out, this building was used as a town hall, a movie theater, and a blacksmith shop. The old schoolhouse was razed in 1953. The small building to the left was the local lockup.

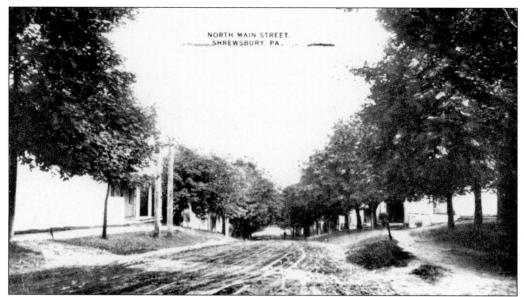

This southward view of North Main Street was printed on a card postmarked June 18, 1918; however, the photograph was taken much earlier, from where Playground Avenue is today. The sidewalks, at least in this area of town, were still dirt paths. Note that the area in front of the houses slopes sharply down to the road. Later, when the road was widened, the hillsides were cut back.

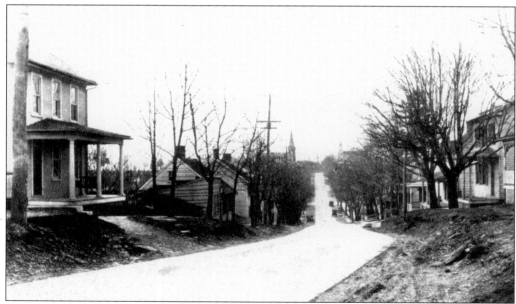

This 1917 view from about the same location shows the hillside cut back and the street paved. Here, the sidewalks are still not paved, but there has been an increase in the number and size of utility poles. The wood-framed house on the left uses stairs to negotiate the cut-back hillside.

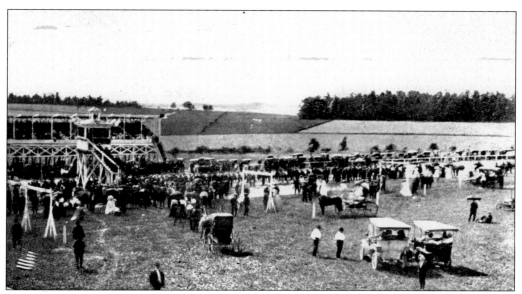

In 1903, the Shrewsbury Trotting and Driving Association began racing at the newly constructed track in the northern part of town. The association was formed by several local businessmen who met at the Shrewsbury Hotel. The racetrack was located on the west side of North Main Street, near the present site of the Assembly of God Church.

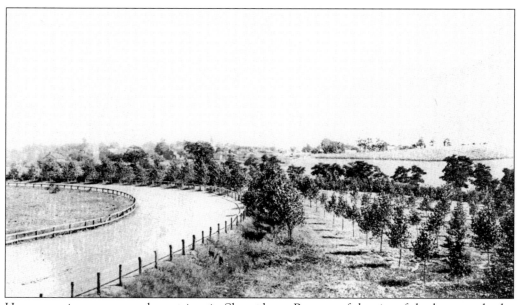

Harness racing was a popular pastime in Shrewsbury. Because of the size of the large track, the spacious infield provided room for many outdoor activities. The infield included a baseball field, a picnic area, and a shooting range.

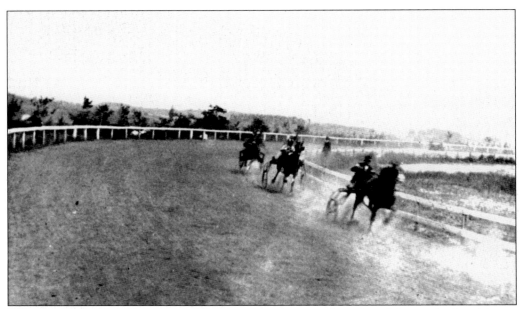

Why the Shrewsbury Trotting and Driving Association collapsed and the track closed is not fully known. Some sources cite a fatal accident on the track and the resulting decline in enthusiasm for the sport. Known as the Shrewsbury Driving Park, the track closed *c*. 1914.

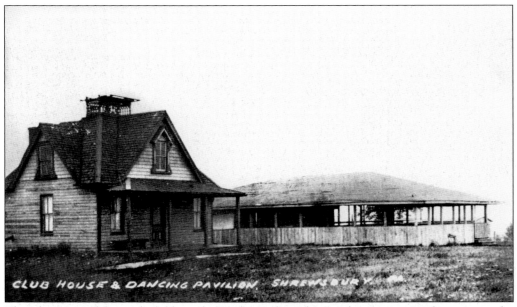

This dance pavilion and clubhouse were located in the northern section of town, on the grounds of the racetrack. The pavilion was used for outdoor activities such as picnics. The clubhouse was used for band concerts and weekend dances. The image indicates that the clubhouse was no longer being used and had fallen into disrepair. It is uncertain when these buildings were razed.

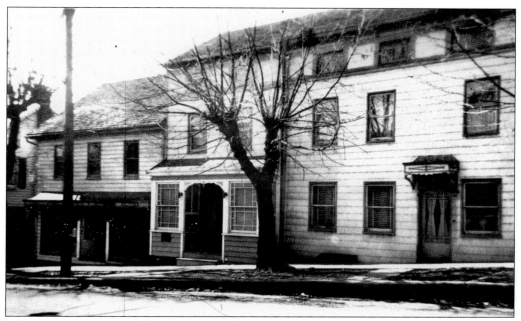

John T. Wagner started his furniture and undertaking business in 1899 on an East Forrest Avenue lot that is now part of Saubel's parking lot. In 1908, Wagner moved the operation to 28–32 North Main Street after he had purchased a furniture store and two homes from John Wolz. This 1930s view shows the furniture store on the left, the funeral home in the middle, and the residence on the right.

In 1946, John Wagner's daughter Martha and her husband, R. Preston Bennett, bought the property from him. They extensively renovated the store and began operating Bennett's Electrical and Furniture there. John Wagner continued the funeral business until his death in 1954. Afterward, the funeral home was converted into a residence.

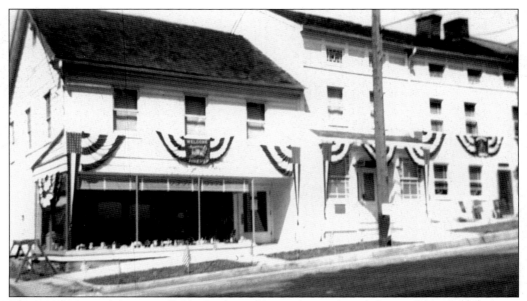

This 1940s view of the store (left), the funeral home (center), and the residence (right) shows that all three underwent extensive renovation. Several large appliances and home furnishings can be seen inside the storefront. The property is decorated for the annual fireman's parade.

The Bennetts closed their furniture store in 1961. In 1976, after retirement, they renovated the store one last time. The glass storefront was removed, the upper floors torn off, and the store converted into additional living space for the family.

The Wagners' and the Bennetts' furniture was manufactured in this structure to the back of their North Main Street property. The vintage automobiles shown in this 1970s photograph are parked against the building along North Sunset Drive, across from the fire company parking lot. The building still stands today.

A number of small mom-and-pop stores operated around Shrewsbury. One such location was at 134–136 North Main Street. This location housed stores named Drenning's, Ziegler's, Striebig's, and Joe and Bill's. When full-service supermarkets began appearing in town, the smaller neighborhood stores began closing.

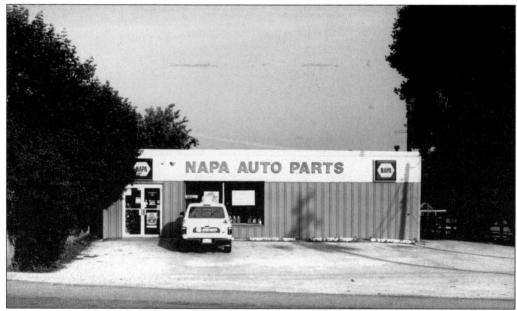

The small metal building housing NAPA Auto Parts was built by Lindy Smith in the early 1970s for slot-car racing. Once the popularity of the hobby had passed, Race-o-Rama closed its doors, and a series of other businesses operated from there, including a machine shop and a ceramics and craft shop. NAPA began business there in the late 1970s.

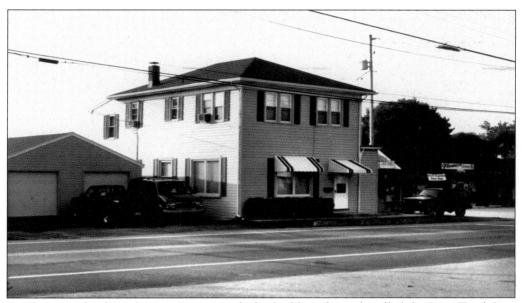

On the east side of North Main Street stands this building, formerly called the Race Track Inn. Although it may not have existed during the time of racing, it obviously was named for its close proximity to the track. When functioning as a business, the inn had a restaurant on the first floor and gas pumps in front. The roof on the front of the building reached out to the edge of the road. Cars would pull under the roof to fill with gasoline.

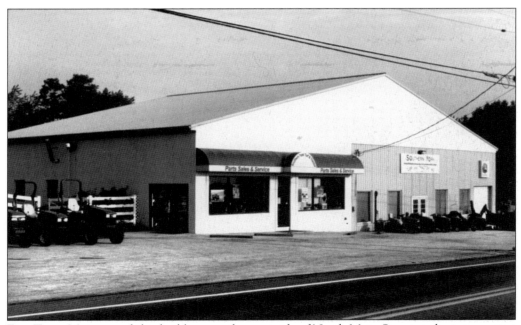

Five Town Motors used this building, on the west side of North Main Street at the intersection of Plank Road, as its showroom. The Ford dealership also used the concrete block building (just out of view to the north) for an auto repair facility. Southern York Turf and Tractor now occupies both buildings as a John Deere dealership.

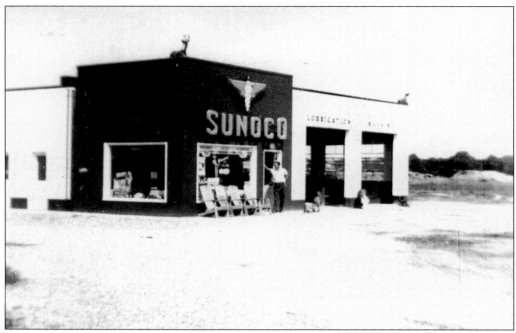

These two images show the Smith Brothers Garage shortly after it was opened by Chet and Lindy Smith in October 1952. The Smiths have made several expansions to the North Main Street business, and today it includes a convenience store and a multi-bay auto repair facility. The lot on the south side (left) of Smith Brothers is now occupied by the Assembly of God Church.

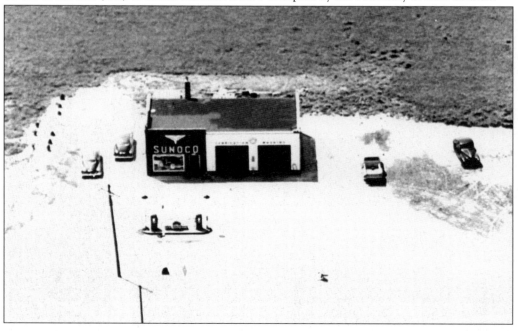

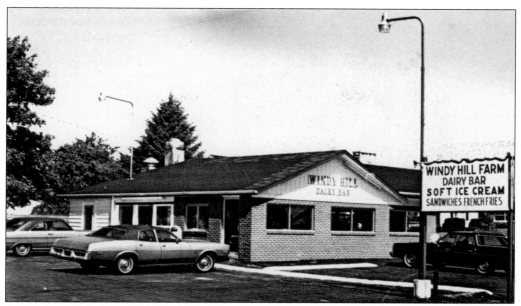

A popular roadside stop from the 1950s to the 1990s was the Windy Hill Farm Dairy Bar. Burgers, hot dogs, shakes, floats, and soft ice cream were the favorite menu items. A fire during remodeling nearly destroyed the building in mid-December 1992. Since then, the food business has moved next door and is operated under a different name. Remodeled and reopened, the original dairy bar building has seen several tenants, including a chiropractor, a health salon, and a hair salon.

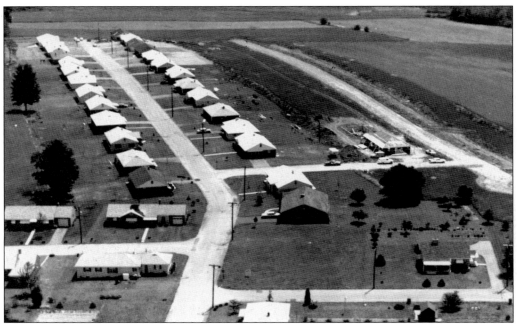

The first major housing development was created in the late 1950s by Raymond D. Krout. This view of the Krout development looks east along East Clearview Drive. The street closest to the bottom is North Highland Drive. Kelly Drive is the street with the vehicles parked closed to the unfinished house. Raypaula Drive is the unfinished street on the right.

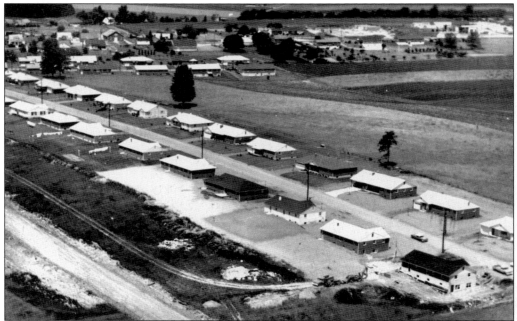

This view looks to the northwest, over the newly built homes on East Clearview Drive. The field behind the houses is now the Brookview Meadow development. In the distance is Smith Brothers Sunoco along North Main Street.

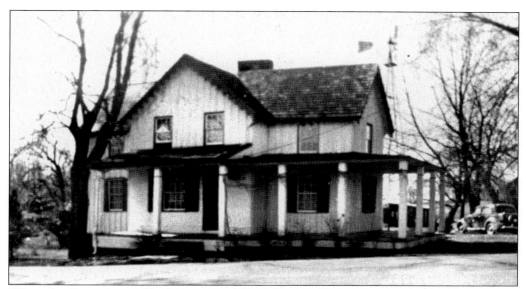

When the Susquehanna Trail was part of the Baltimore-York Turnpike, this building, on the future Thompson Potato Farm, was one of the many tollhouses along the way. The house is along the west edge of the highway. The toll collector would collect a nickel from the driver of each car or horse. Many stories have been told about the circuitous routes people would take to avoid the 5¢ toll. Behind the house, the windmill pumped water from a well on the property. The existing Thompson residence was built behind this house in 1950. This structure was razed, and the site is now the front yard of the newer home.

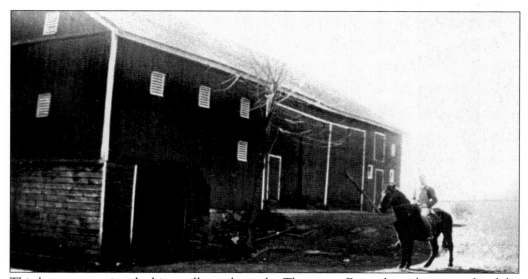

This barn, now painted white, still stands on the Thompson Farm along the west side of the Susquehanna Trail. Several additions have been made, but its original configuration can be seen in this 1930s photograph.

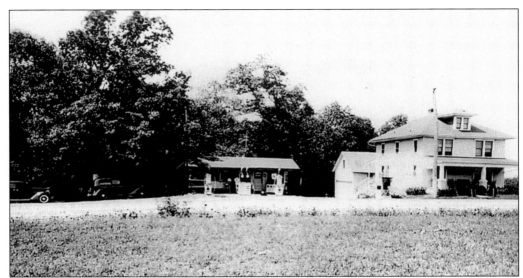

Ehrhart's Service Station stood in the small grove of trees on the west side of the Susquehanna Trail, at the top of the hill just north of the Thompson Farm and just south of White's Garage. Also known as the Shady Grove Inn, this location was a popular gathering place to listen to the string bands playing on summer evenings. Although the buildings on the left are long gone, the house on the right remains.

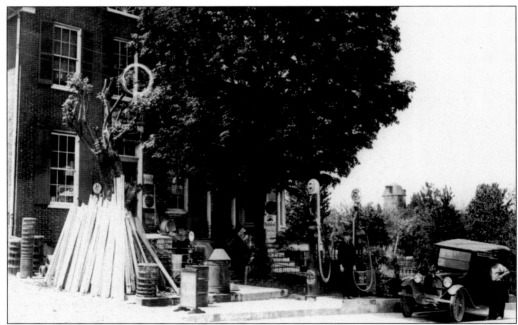

This recognizable building is located along the west side of the Susquehanna Trail in Hametown, across from the Shrewsbury Township Building. It dates back to the 1800s and has been in almost continual use as a general store and an antique store. C. A. Saubel started the family grocery business here in the 1920s. This early photograph reveals the days when the store sold Gulf gasoline.

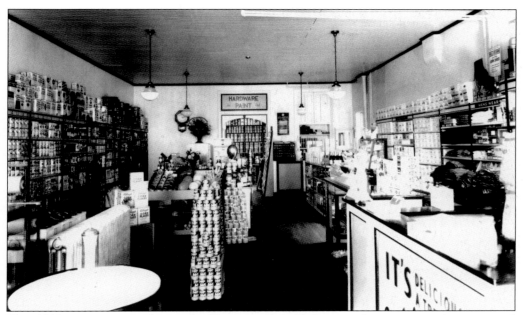

This 1940s interior view depicts the Hametown establishment when it operated as a general store. The mixture of foodstuffs, clothing, sewing products, shoes, hardware, and paint demonstrates its ability to provide complete services to the small community. The store also had a soda fountain and served ice cream.

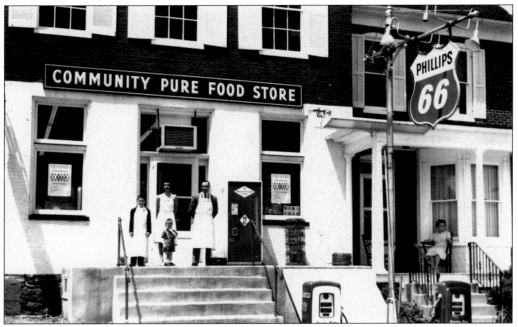

Leon and Doris Saubel operated the same shop as a grocery and a Phillips 66 station, as shown in this early-1960s photograph. The family built a larger grocery store on East Forrest Avenue in Shrewsbury and moved there in 1966. Standing in front of Leon and Doris are their two sons, Steve (left) and Greg.

One of the longest living legends in the Shrewsbury area is that of the November 1928 Hex Murder in Rehmeyer's Hollow in nearby North Hopewell Township. Because the murder involved witchcraft and the occult, the investigation and subsequent trials received worldwide attention. This photograph, taken the morning that Nelson Rehmeyer's body was discovered, shows a number of police vehicles at the scene.

Three

SOUTH OF THE SQUARE

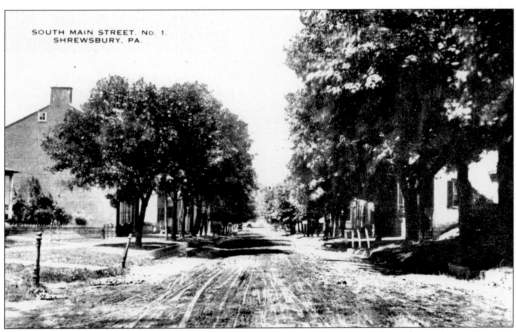

SOUTH MAIN STREET. No. 1.
SHREWSBURY. PA.

This early-1900s postcard view looks north from the front of the Shrewsbury Savings Institution (the former borough library). The sidewalks have been paved, but the street has not. At the time, the brick house on the left, at 38 South Main Street, was the parsonage for the Methodist Episcopal church at 108 South Main Street.

This undated postcard view likely looks south toward Turnpike (Hungerford). The street has not yet been paved and the walkway on the right is still a dirt path, indicating a scene dating from the second decade of the 20th century.

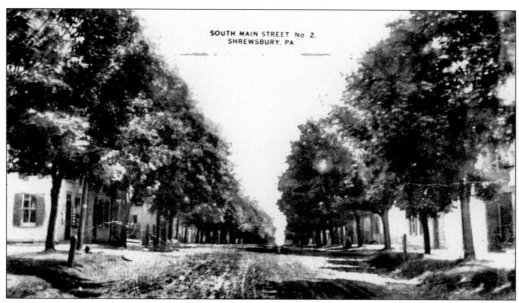

SOUTH MAIN STREET No 2.
SHREWSBURY, PA

Many of the houses shown on this early-1900s postcard are still standing. Houses of this style, a combination of one door and two windows, are known as Shrewsbury Vernacular. Through the years, these houses have seen many modifications and improvements, but their basic appearance remains the same.

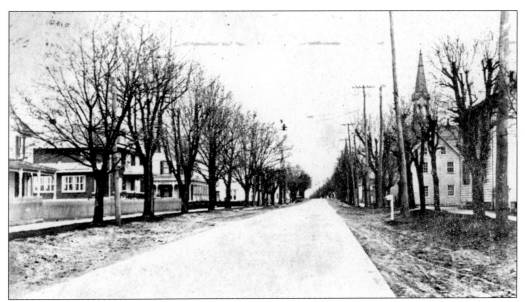

This card, postmarked 1932, depicts a northward view of South Main Street from the front of the Brethren Church. Although the street has been paved and the sidewalks built, this section of town has not yet seen curbs and improved shoulders. The trees lining the street were planted in honor of the York County veterans of World War I. The closest steeple on the right is St. Paul's United Church of Christ.

The congregations of the Brethren Church had been meeting in homes for more than 150 years before this church was built on South Main Street in 1912. Part of the congregation split eight years later and formed the Dunkard Brethren Church. The Dunkard congregation still meets in a brick church on the west side of North Main Street.

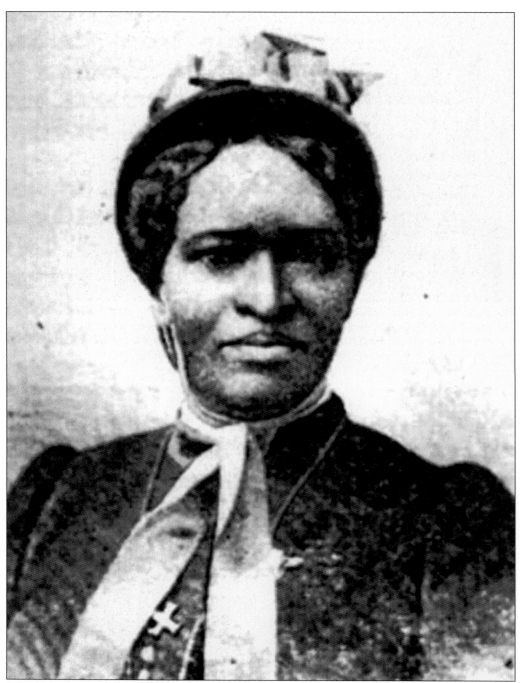

Born a slave in Maryland, Amanda Berry moved to a farm south of Shrewsbury after her father had bought the family's freedom. Working as a servant for a town widow, Amanda attended the Methodist Episcopal church at 108 South Main Street in Shrewsbury with four other members of her family. At the church, she received her calling and began a 65-year career as an evangelist and gospel singer.

AMANDA BERRY SMITH (1837-1915)

A renowned evangelist and singer, born a slave in Maryland. Her father bought the family's freedom, and they moved to a farm near here. While still a child she was converted at this church. She committed her life to missionary work and traveled in the U. S. and to Britain, India, and Africa. Published a monthly paper, "The Helper." Founder and superintendent, Industrial Home for Colored Children in Illinois.

PENNSYLVANIA HISTORICAL AND MUSEUM COMMISSION 1993

The Pennsylvania Historical and Museum Commission erected this marker in 1993 in front of the then Grace United Methodist Church at 108 South Main Street to honor the life and ministry of Amanda Berry Smith. The former-slave-turned-evangelist is one of two Shrewsbury residents honored by such historical markers.

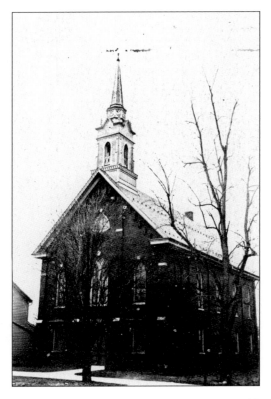

The Methodists and the Evangelicals were the first congregations to build a church in Shrewsbury. In 1821, that church was built of logs at the intersection of West Forrest and Park Avenues. The church was destroyed by a tornado in 1840, and the Methodists built a one-story brick sanctuary on this site in 1850. After that building was destroyed by fire, it was replaced by this two-story brick church, completed in 1877.

Because of very little parking space, one small restroom, and an expanding congregation, the Grace United Methodist congregation moved into its new church at 473 Plank Road in December 2001. The old building was sold to a private individual, who then renovated it into a family residence.

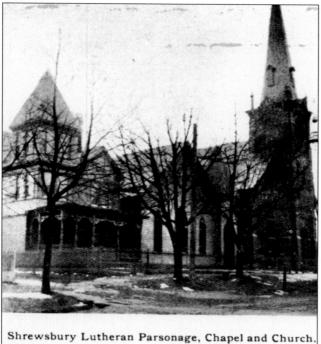

Shrewsbury Lutheran Parsonage, Chapel and Church.

Across the street from the Methodist church is Christ Lutheran Church, which was completed in 1875. In 1880, the congregation built a chapel on the left side of the church. In 1913, to make room for an expansion, the chapel was raised, rolled back (east), and then rolled left (north) and placed behind the parsonage, all without the benefit of today's heavy equipment. The chapel is still used as the church's fellowship hall.

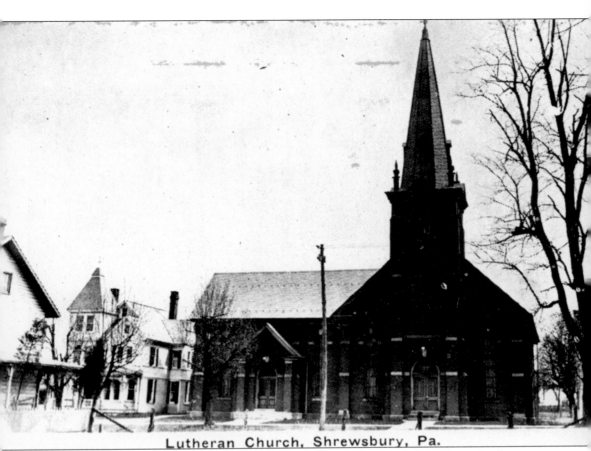

Lutheran Church, Shrewsbury, Pa.

Christ Lutheran Church is pictured after the chapel was relocated and the addition built in its place. Today, the church's office is located in the parsonage building on the left. The house at extreme left is currently an antique store at 104 South Main Street. To the right, the white house with the dark shutters is no longer standing.

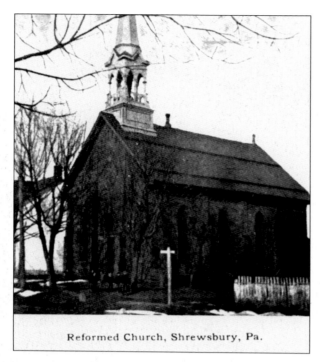

Reformed Church, Shrewsbury, Pa.

St. Paul's United Church of Christ was first built as Solomon's Reformed Church. After several mergers, it became the United Church of Christ in 1957. Over the years, the church has undergone several modifications, including the razing of the original parsonage and the addition of an education building in 1975. The bell tower was struck by lightning in 1940, catching fire. When the wooden tower was replaced by an aluminum one in 1987, some of the charred wood was preserved in a case that hangs in the church entrance.

Rev. Charles M. Mitzell was the Solomon's pastor from 1924 to 1947. The Mitzells had seven children, one of whom was Cameron. After graduating from high school in New Freedom, Cameron changed his last name to Mitchell and pursued an acting career in Hollywood. Cameron Mitchell made 159 movies and two TV series. He is probably best remembered for his role as Buck in the 1960s series *High Chaparral*.

42

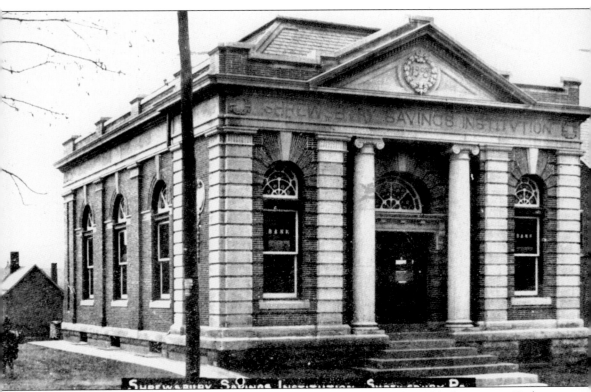

The Shrewsbury Savings Institution was incorporated on June 6, 1850, becoming York County's second bank. This 1909 postcard shows the Shrewsbury Savings Institution building when it was just a year old. Located on the northwest corner of South Main Street and West Railroad Avenue, the bank operated until 1929, when it was forced to close because of the Great Depression. In the left background is the Shrewsbury Public School, which serves today as the borough building.

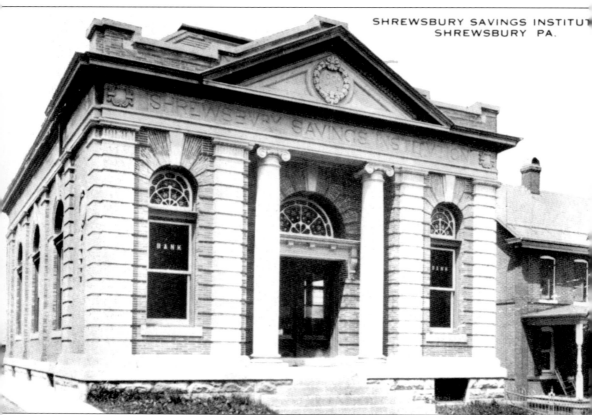

This 1921 postcard shows no significant change in the building. After the Shrewsbury Savings Institution closed, the town was without a bank until the York Trust Company opened a branch here in 1935. The building remained a bank until the York Bank and Trust moved to a larger facility on East Forrest Avenue in 1979. After the bank gave the building to the borough, it was converted it into the town library. The library operated from this location until 2003.

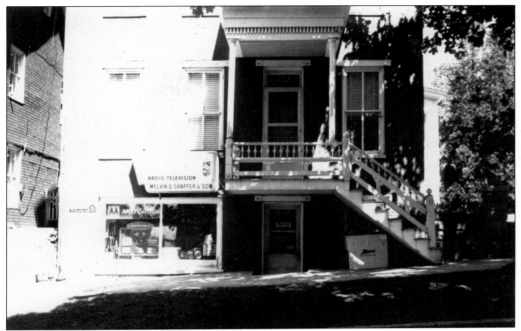

Melvin Shaffer moved his electronics business and residence from East Forrest Avenue to 39 South Main Street in the late 1930s. The family residence occupied the three floors above the shop. The business remained there until Harold Shaffer moved it to Plank Road in 1964. Dr. E. H. Gerry operated a medical practice from this location beginning in 1896. This building was razed in 1974 and replaced by the single-story brick rancher occupying the site today.

This March 1962 photograph depicts the back of 39 South Main after a significant snowstorm. Of note are the outbuildings, including the brick smokehouse. Various types of outbuildings still exist in the backyards of the houses in the Historic District. They are readily observed by walking Sunset Drive, Highland Drive, and the narrow cross avenues.

This view looks south from the front of 39 South Main Street, before the York Bank moved from the Shrewsbury Savings Institution building. The house just beyond the bank stands on the southwest corner of West Railroad Avenue.

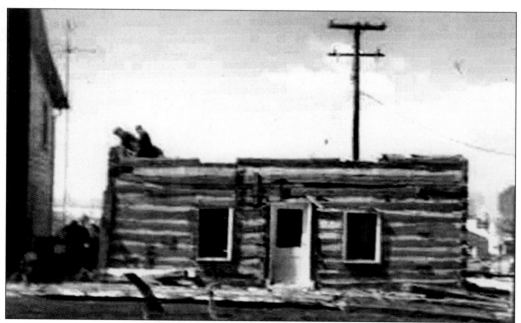

In 1974, while workmen were dismantling an ordinary wood-frame house at 102 South Main Street, they discovered one of Shrewsbury's many log houses under the façade and siding. Today, 17 old log houses still exist in town. This lot stood vacant for many years until the community Christmas tree was planted there.

In November 1981, an evergreen tree was planted in the lot on the southwest corner of South Main Street and West Railroad Avenue. Each Christmas season since, the tree has been decorated with lights and then illuminated during a brief ceremony. In 2003, the original tree was replaced with this smaller evergreen, and the tradition continued.

In 1952, the Shrewsbury Post Office moved from West Forrest Avenue, a location it had occupied since 1889, to this facility at the intersection of West Railroad Avenue and South Sunset Drive. It remained at this location until moving to the south end of the borough in April 1996. This building is now occupied by a private business. Because the Shrewsbury Post Office has no rural delivery service, locations very close to the borough on all sides have either a New Freedom or a Glen Rock mailing address.

This complex along Constitution Avenue houses the Shrewsbury Post Office, the Southern York County Library, and the Southern York County YMCA. The YMCA, complete with an indoor pool, is in the former Roller-Land skating rink. The post office and library are in newly constructed buildings.

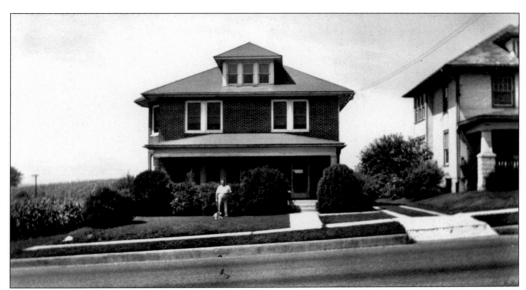

This 1940 view shows 248 South Main Street. At the time, Shrewsbury's southern border with Shrewsbury Township was a few yards away. The borough expanded south and annexed Hungerford 20 years later. Today, this building houses Silbaugh Memorials. The cornfield to the left is now the lot where the head stones and memorial markers are displayed.

Joseph and Charlotte Silbaugh stand in front of their residence at 248 South Main Street in the 1940s, when open fields occupied the east side of the street. In the distance is the water tower at the Chase Bronze and Copper Screen Cloth facility in Hungerford. The wire cloth business closed in 1980, but the water tower remained for several years in the Shrewsbury skyline. It was removed when the old factory building was renovated to make Shrewsbury Courtyard.

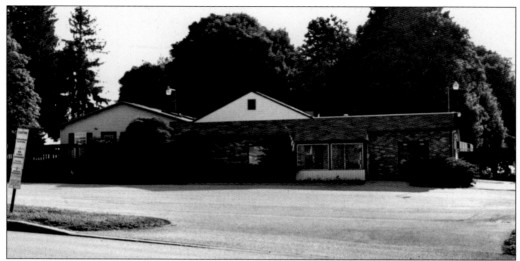

A Touch of Country Day Care Center is located at 245 South Main Street. Before becoming a day-care facility, the building housed Lehman's Flower Shop. In the rear of the flower shop was a greenhouse. The southern boundary of Shrewsbury was located in this general vicinity prior to the annexation of Hungerford's 200 acres. Shrewsbury's southern edge would eventually move more than a mile south to its present location, just north of Strawberry Road.

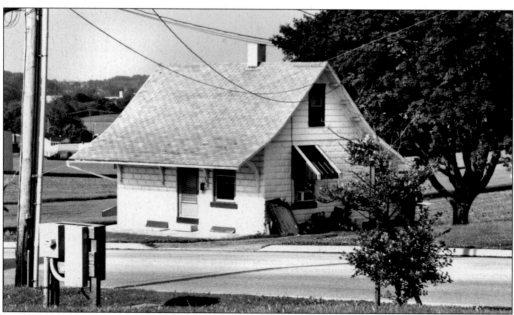

Located at 304 South Main Street is a small bungalow-style dwelling that is often mistaken as one of the old tollhouses along the Baltimore-York Turnpike. In fact, the house was built by Jack Sweitzer in the late 1940s. It is still a residence.

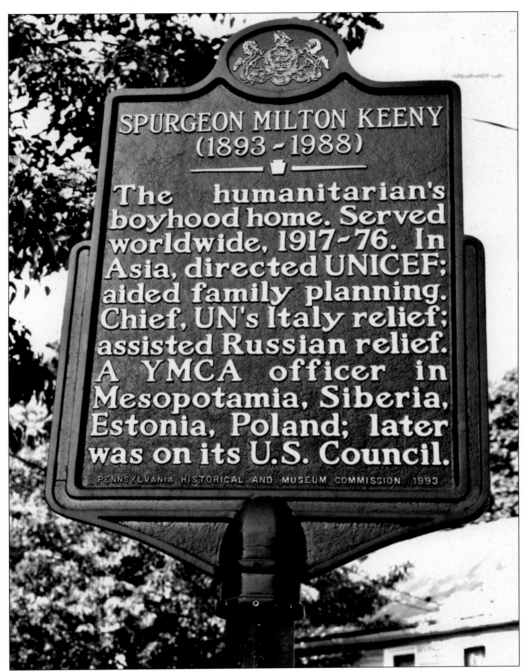

SPURGEON MILTON KEENY
(1893 - 1988)

The humanitarian's boyhood home. Served worldwide, 1917-76. In Asia, directed UNICEF; aided family planning. Chief, UN's Italy relief; assisted Russian relief. A YMCA officer in Mesopotamia, Siberia, Estonia, Poland; later was on its U.S. Council.

PENNSYLVANIA HISTORICAL AND MUSEUM COMMISSION 1993

In 1993, the Pennsylvania Historical and Museum Commission erected this historical marker to commemorate the life and achievements of one of Shrewsbury's most notable residents, Dr. Spurgeon M. Keeny. Born in Tolna, Keeny grew up in Shrewsbury, graduated from Gettysburg College, and went on to be a Rhodes scholar in Oxford, England. After years of humanitarian service, Keeny retired in Washington, D.C., where he lived until his death at age 95. This marker is in the front yard of Keeny's boyhood home at 155 South Main Street.

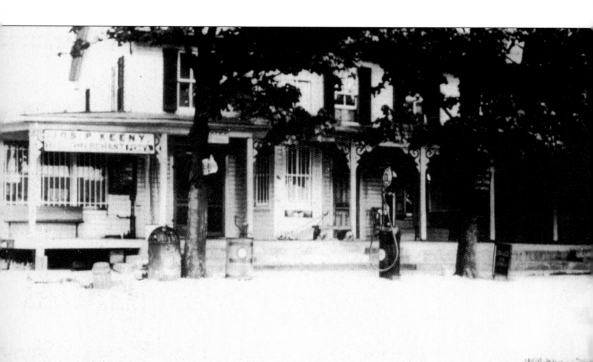

H. W. Rehmeyer built and operated this small general store in Turnpike where the Stewartstown Railroad crosses the Susquehanna Trail (South Main Street). He later sold the building to Joseph Keeny, who also operated a store there. When this photograph was taken, likely between c. 1915 and c. 1925, Keeny was the postmaster of the Turnpike Post Office. Years later, when Harry Albrecht was postmaster, the post office was moved across the tracks to the old freight station. Through the years, this building housed many different types of businesses, including Thomas' Meats. It was also home to an office supply store, a used bookstore, and a ceramic shop. Today, it is occupied by Alexander's Jewelry and the Violin Studio of Shrewsbury.

This building was constructed by H. W. Rehmeyer in 1923 as a Ford dealership, where Model T and Model A Fords were sold. The dealership, Hungerford Motors, closed in 1932. The building's spacious interior made it an ideal location for weekend square dances and round dances beginning in the 1930s. In later years, it was used by Strawbridge Implements to sell farm machinery. Numerous buildings in the Hungerford crossing area were built by H. W. Rehmeyer, including the old Anderson Feed Mill and the house on the northeast corner of South Main Street and Tolna Road that once housed M & C Shoes and several restaurants.

In this view, looking north across the tracks in Turnpike (Hungerford), the vehicle indicates a date in the second decade of the 20th century. The building on the right is where the old freight station is today. To the photographer's immediate right is Joseph Keeny's Store, now Alexander's Jewelry.

This northward view captures South Main Street at Tolna Road. Years ago, another set of tracks crossed South Main Street on the north side of the old freight station, in order to access the coal trestle servicing the Hungerford Packing Company. The white house on the left, with the trees and the fence in front, is 422 South Main Street. During a winter storm in 1819, Andrew Jackson stopped there on a trip to York. At the time, the house was an inn operated by Cornelius Garrettson.

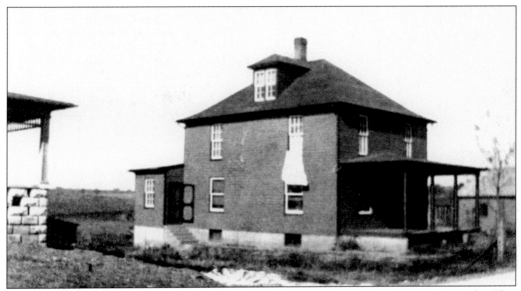

This house and the one to the left are at 512 and 514 South Main Street, respectively. This 1930s photograph shows the houses when the area was known as Turnpike. The name of the area would change to Hungerford and later to Shrewsbury when the borough annexed the village. The house on the right was then the residence of Harry Albrecht.

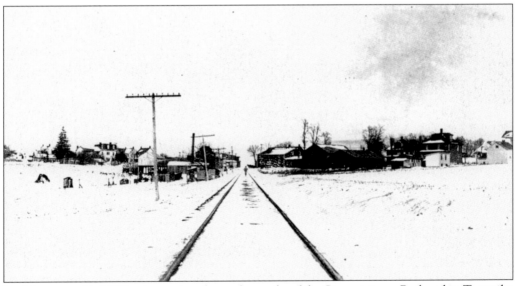

Looking east, this 1930s winter view shows the tracks of the Stewartstown Railroad in Turnpike (Hungerford). The house on the right, with the chimney and dormer, was the Albrecht residence at 512 South Main Street. The field to the left of the tracks would later be occupied by the buildings of the Hungerford Packing Company. This image was taken in the area where Onion Boulevard crosses the railroad tracks.

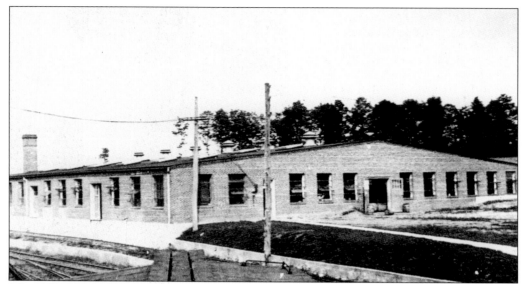

John Albrecht took this photograph of the screen cloth plant in the 1930s by climbing to the top of a boxcar. During World War II, the plant made screen wire that was used in some of our bombers. It also provided materials for the Manhattan Project, the development of the atomic bomb. In 1997, the abandoned plant was converted into the Shrewsbury Courtyard retirement apartments. Elwood Henry worked in the plant for 37 years and now resides in an apartment in the same area as his former workspace.

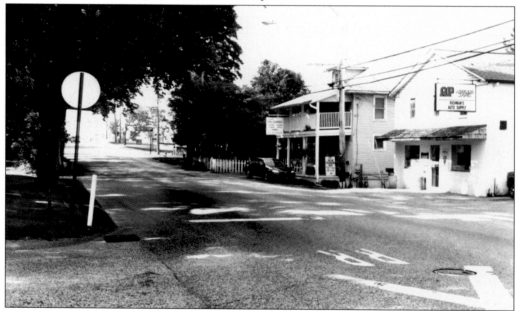

Jack Kiser operated a small store and the Hungerford Post Office from 510 South Main Street. When Shrewsbury Borough annexed Hungerford in 1965, there was no longer a need for the Hungerford facility. Today, Amy's Nail Classics operates from the building. Richman's Auto Supply, at right, was the original site of "Hap" Trout's plumbing business. The former Albrecht residence, at 512 South Main, is hidden by the trees behind the fence.

Alan Rehmeyer built the packing company that extended from the Hungerford crossing south beyond Onion Boulevard on the west side of South Main Street. William A. Free bought the company from Rehmeyer and operated it into the 1970s. Many of the cannery buildings are now used by other businesses in the Hungerford section of town.

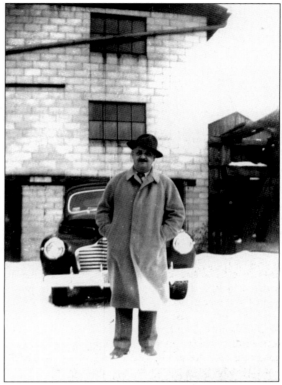

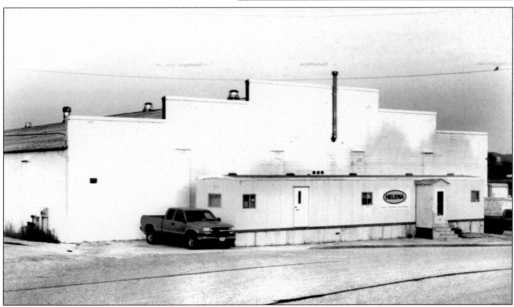

Pictured here is one of the many Hungerford Packing Company buildings still being used. The red-brick building at the intersection of South Main Street and Onion Boulevard, where the Subway shop is housed, served as the administrative offices of the business. The packing company was one of the largest employers in the Shrewsbury-Hungerford area.

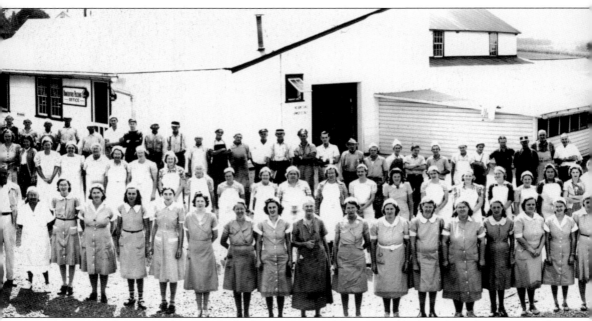

This September 1941 photograph displays just part of the Hungerford Packing Company work

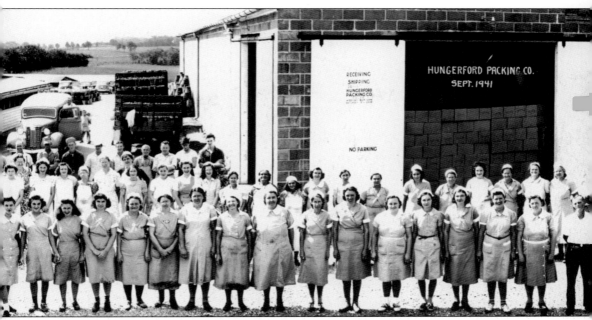

force. Even three months before Pearl Harbor, the majority of the employees were women.

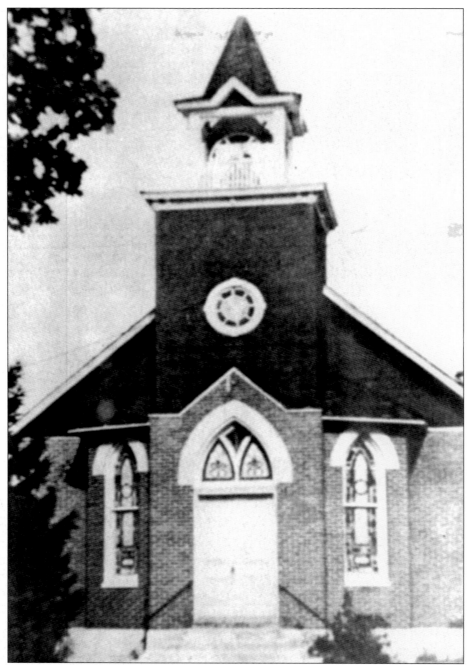

The original Turnpike Baptist Church was built in 1923 and stood on the northeast corner of South Main Street and Sheffer Avenue. The parsonage was erected in 1956 on the lot adjacent to the north side of the church. In 1963, a new sanctuary was built behind the older one, and the church pictured here was torn down to allow for a paved parking lot. Although the village of Turnpike changed its name to Hungerford, and then to Shrewsbury when it was annexed into the borough, the Baptist church retained the name Turnpike.

The Sheffer farm is one of the farms on which the Southern Farms housing development was built. This 1958 photograph was taken in a field that is now the backyard of some of the houses on Covington and Crosswinds Drives.

This view of the Sheffer farmhouse, now the Coulter residence, was taken from a hillside within the triangle formed by the upper part of Strassburg Circle, Covington Drive, and Crosswinds Drive. At the time, little existed on the surrounding land except another Sheffer family farm to the north and the Shrewsbury Gun Club at the end of Winchester Drive.

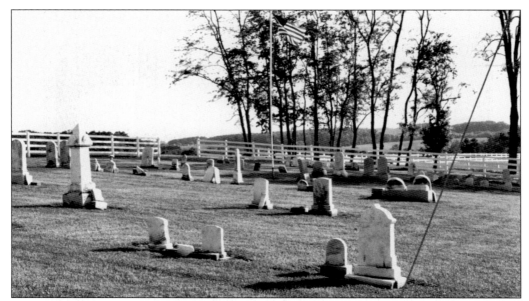

Rock Chapel Cemetery is located in southern Shrewsbury Township, east of the Susquehanna Trail. It is the final resting place of veterans of the Revolutionary War, the War of 1812, and the Civil War. For years, this cemetery was overgrown with trees, briars, weeds, and poison ivy. In the late 1990s, however, the cemetery was restored through the tireless efforts of volunteers from Mammy Ruggles Tent No. 50, the Boy Scouts, the Eagle Scouts, and private citizens.

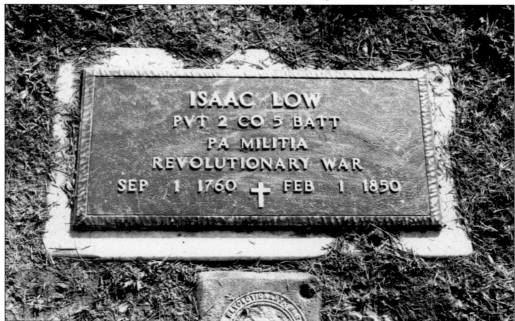

Some of the headstones were either broken or so badly weathered as to be unreadable. Most of the broken grave markers were repairable. In some cases, replacement markers were obtained and placed as appropriate. The efforts of the volunteers have restored the cemetery to a well-kept, peaceful, and respectful resting place.

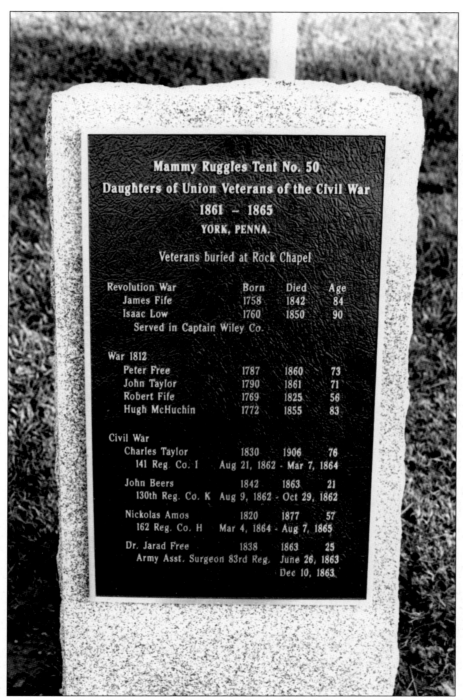

Mammy Ruggles Tent No. 50
Daughters of Union Veterans of the Civil War
1861 – 1865
YORK, PENNA.

Veterans buried at Rock Chapel

Revolution War	Born	Died	Age
James Fife	1758	1842	84
Isaac Low	1760	1850	90
Served in Captain Wiley Co.			

War 1812			
Peter Free	1787	1860	73
John Taylor	1790	1861	71
Robert Fife	1769	1825	56
Hugh McHuchin	1772	1855	83

Civil War			
Charles Taylor	1830	1906	76
141 Reg. Co. 1 Aug 21, 1862 - Mar 7, 1864			
John Beers	1842	1863	21
130th Reg. Co. K Aug 9, 1862 - Oct 29, 1862			
Nickolas Amos	1820	1877	57
162 Reg. Co. H Mar 4, 1864 - Aug 7, 1865			
Dr. Jarad Free	1838	1863	25
Army Asst. Surgeon 83rd Reg. June 26, 1863			
Dec 10, 1863			

Pictured here is a list of the veterans buried in Rock Chapel Cemetery. The original Rock Chapel Church was located in the valley just south of the cemetery. It was later replaced by a second Rock Chapel Church, which stood on the south end of the present Shrewsbury Family Restaurant parking lot. Neither structure exists today.

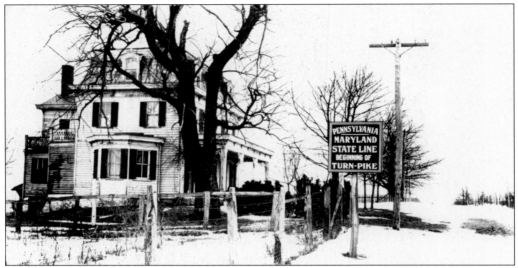

This December 24, 1917, photograph at the Mason-Dixon Line shows the first tollhouse in Pennsylvania on the Baltimore-York Turnpike. The house was built in 1870. Across the roadway, on the land now occupied by the Mason-Dixon Farm Market, there once stood a country store and, in later years, a mobile-home sales business.

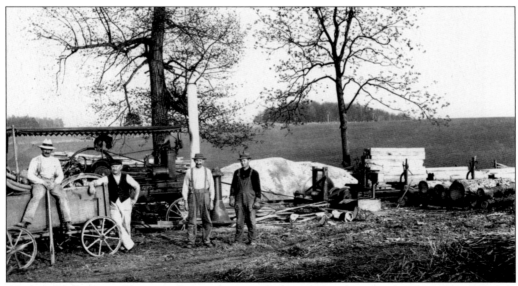

Workers at this portable sawmill operation pause for a 1914 photograph. This type of mobile operation moved from site to site and converted standing timbers into usable lumber for the landowner. Although the exact location depicted here is unknown, it could possibly be the fields west of the Susquehanna Trail near the Mason-Dixon Line. The woods in the right background strongly resemble those on the northeast corner of the intersection of the Susquehanna Trail and Stewartstown Road (formerly Miller Road). The woods to the left resemble woods farther north, on the west side of the trail.

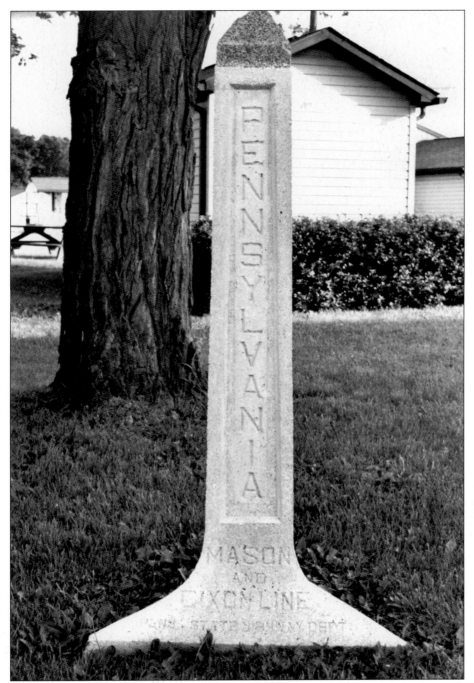

The Mason-Dixon Line, surveyed in 1767, is the dividing line between southern Pennsylvania and northern Maryland. In the mid-1800s, it became the symbolic division between the North and the South. This marker designates the line on the Mason-Dixon Farm property. Through the efforts of a young Eagle Scout, it replaced a similar marker that had been damaged. The base is inscribed, "Eagle Scout Project, William Scavone, Restored October 7, 1989."

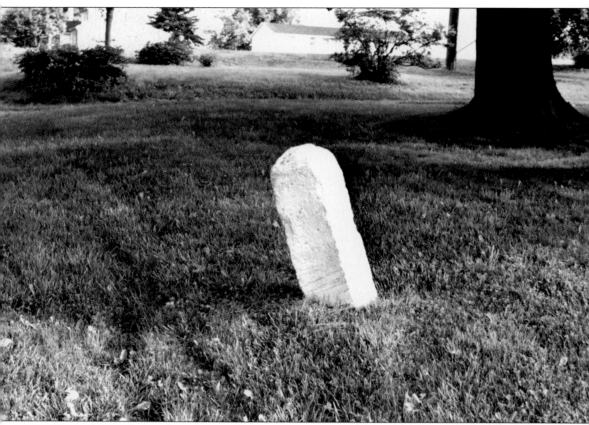

Throughout the 1800s, the road that we know as the Susquehanna Trail was a major transportation route linking Baltimore, York, and Harrisburg. Distances along the route were designated by sandstone markers like this one, located in the front yard of the Paul King residence, about a half-mile north of the Mason-Dixon Line. The years have obviously taken a toll, as no markings are discernible. It is leaning as a result of a traffic accident.

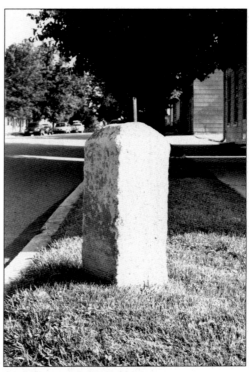

Another of the sandstone markers (right) is on the east side of South Main Street in Shrewsbury Borough. Like the markers to the south, this one no longer bears any distinguishable etchings. This marker can be found between the sidewalk and the curb in front of 147 South Main Street (below). At least two other markers are known to exist in the general area. One of the other markers is on South Main Street between Virginia Avenue and Essex Circle. The other one is north of Shrewsbury in Hametown. All four markers were placed on the east side of the roadway.

SHREWSBURY

FOUNDED IN

1794

BY BALTZER FAUST

THIS VILLAGE has been placed

on the NATIONAL REGISTER

of Historic Places.

Signs of this type appear at several locations around the Historic District of Shrewsbury and note the town's founder, Baltzer Faust. This sign also notes that the district has been placed on the National Register of Historic Places. Care was taken to ensure that the signs were held by old-style wooden posts.

Four

EAST OF THE SQUARE

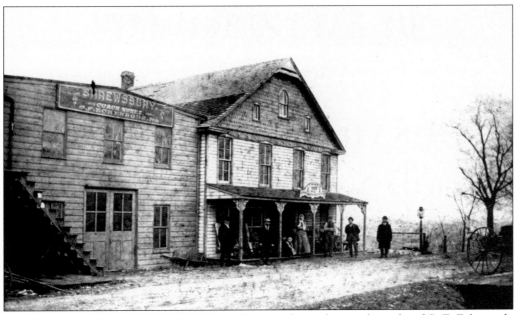

This late-1800s photograph of East Forrest Avenue shows the coach works of S. F. Eckenrode on the left and the cabinetmaking and undertaking business of John Thomas Wagner on the right. The building was located on the north side of East Forrest Avenue, between the Factory and Saubel's Grocery. In later years, the building was occupied by a sewing factory and a restaurant.

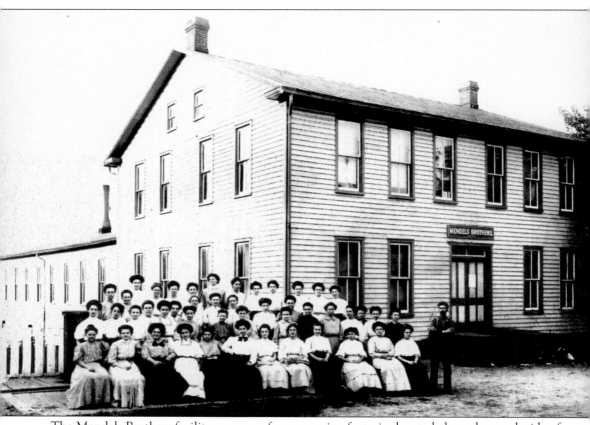

The Mendels Brothers facility was one of many sewing factories located along the north side of East Forrest Avenue. Another sewing business and a cigar factory are reported to have preceded Mendels at this site. This building is readily recognizable today at 45–47 East Forrest Avenue.

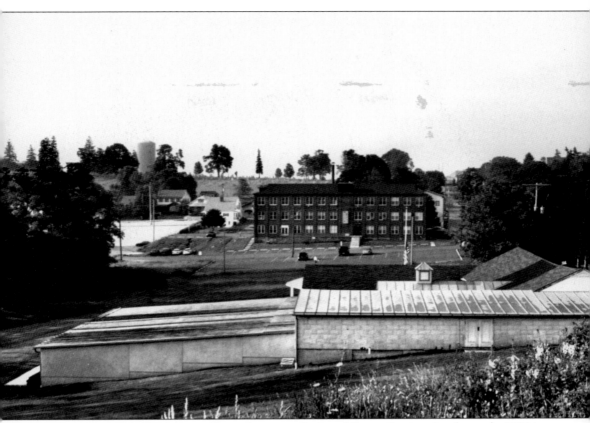

The largest sewing operation in Shrewsbury was Steiner-Liberty Sewing. In the early 1900s, Steiner-Liberty built a three-story brick building along the north side of East Forrest Avenue. The factory remained in continuous operation until December 1978, when it closed its doors. The building was later renovated for offices and small businesses and is now known locally as "the Factory."

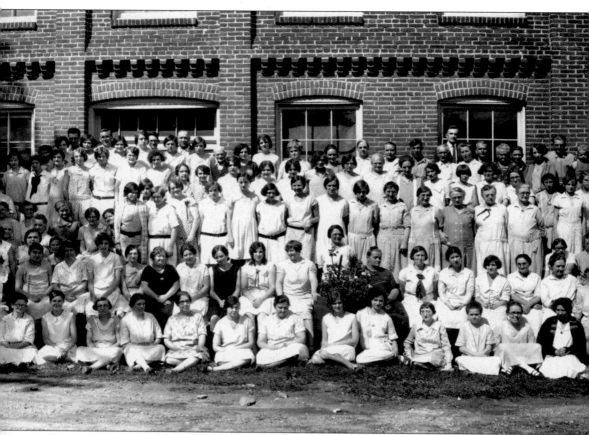

Workers at the Steiner-Liberty Manufacturing Company on East Forrest Avenue are photographed in September 1929. Steiner-Liberty produced women's nightwear, including flannel pajamas. Shrewsbury's location on a major north–south highway route and its close proximity to the rail facilities in Railroad undoubtedly aided in this success.

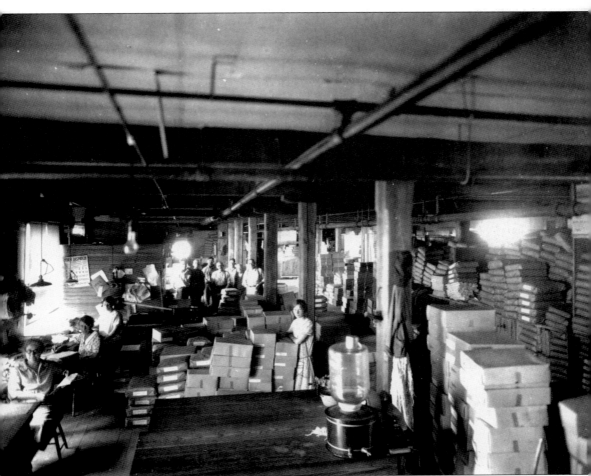

This September 19, 1929, image of the Steiner-Liberty shipping department indicates that the company was very productive and profitable. The close quarters and the amount of flammable material shown here leave little doubt why fire was such a major concern in the garment industry. One must wonder what this room looked liked one month later, after the stock market crash.

Taken on September 14, 1965, the photograph to the left depicts a small vacant lot along the north side of East Forrest Avenue. The sign in the lot reads, "Future New Site of Saubel's Super Thrift." The image below was taken two days later, on September 16. The lot had been scraped clean and leveled. Construction of a grocery store would begin shortly. Saubel's development of this lot was one of the first modern commercial expansions along East Forrest Avenue.

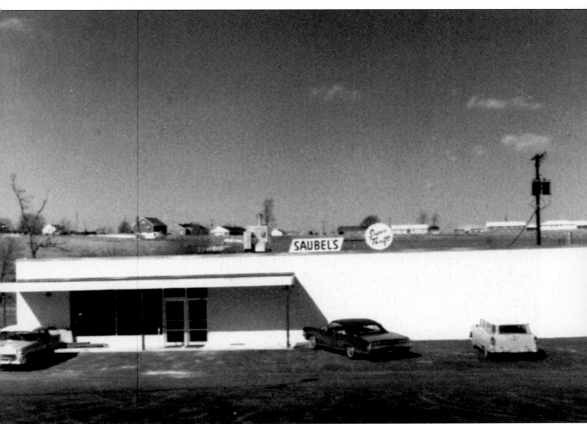

Saubel's moved its grocery operation from the small Hametown store to this larger East Forrest Avenue location in 1966. Over the years, several additions enlarged the store. The first houses to be built in the Krout development can be seen in the background. Within a few years, the development would spread closer down the hillside, near the back of this building.

Taken from the Saubel's parking lot, this October 1979 photograph shows the building of the Shrewsbury branch of the York Bank and Trust at 69 East Forrest Avenue. Upon completion, the financial institution moved from 42 South Main Street to this location. Today, the building houses the Shrewsbury branch of M & T Bank.

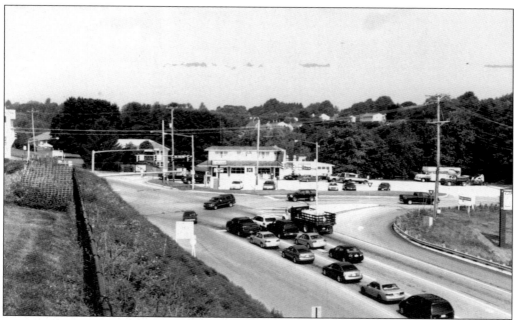

The Coach Light Restaurant, at the intersection of East Forrest Avenue and Mount Airy Road, was built by Warren M. Dill in 1958 as a combination restaurant and Atlantic Richfield gas station. When the gasoline business became too demanding, the pumps were removed and only the restaurant remained. Dill sold the business to Jim and Romaine Fager in 1968. The current owner and operator of the restaurant is Jim Fager Jr.

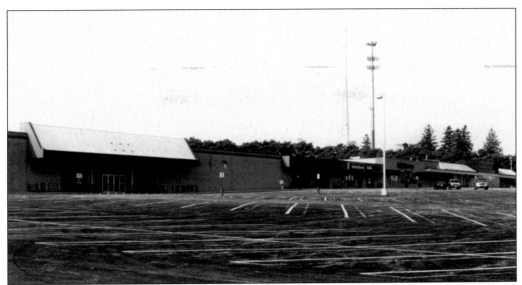

Market Square was the first major shopping center in Shrewsbury when it opened in 1974 in Southern Farms. The K-Mart–Giant shopping center opened on the south side of East Forrest Avenue 10 years later. The plaza was profitable for about 15 years, until more stores moved into the area with the opening of Shrewsbury Commons. K-mart lasted a couple of years but was forced to close because of dwindling sales. Giant and Hallmark moved to Shrewsbury Square in 2003.

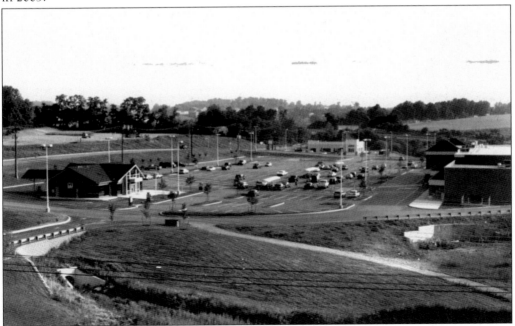

Shrewsbury Square was built in the wedge defined by Interstate 83, Mount Airy Road, and East Forrest Avenue. The shopping center opened in 2003 with Giant Foods as the anchor store. Previously, the area was occupied by the Gordon Glatfelter residence and Blossom Valley Farms landscaping.

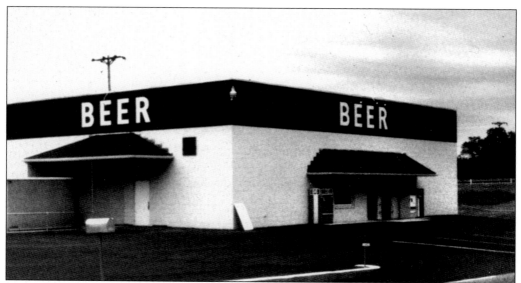

Case & Keg has occupied the same location at the Shrewsbury interchange of Interstate 83 for nearly 30 years. Shown here in 1976 in its original paint scheme, this business has lasted the test of time, while other smaller beverage distributors have come and gone. Because of its close proximity to the interstate, heavy traffic congestion would occur when the Pennsylvania Lottery was offering large prizes. Out-of-state residents passing through the area would stop here to buy their hopeful winning tickets.

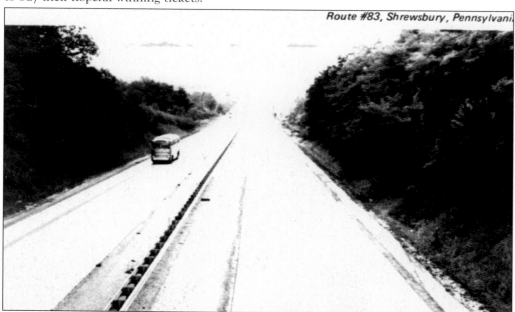

Route #83, Shrewsbury, Pennsylvani.

This 1960s view of Interstate 83 is drastically different from today's view. The lack of heavy traffic indicates that the riches of southern York County have yet to be discovered. When the interstate first opened in 1960, it shifted most of the transient traffic from the Susquehanna Trail (Main Street) and ultimately had an economic impact on many of the small businesses that lined the street in Hungerford and Shrewsbury.

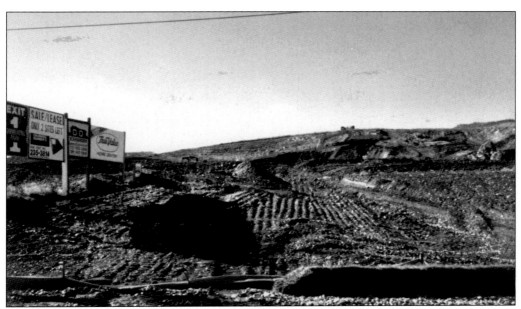

The Bob Hittie family, owners of New Freedom Hardware, undertook a major commercial development on the east side of Interstate 83 in 1988. The family bought farmland owned by the Ray Keeny family adjacent to the south side of Route 851 and began building a large hardware and home improvement center there.

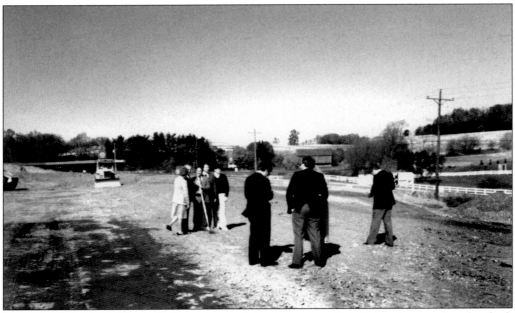

The Hittie family gathers with financiers and developers to officially break ground and to look over the future site of the True Value Plus Home Center. The old Wolf Farm can be seen in the distance along the north side of Route 851. A restaurant briefly operated in the farmhouse before it was razed. The sign above the bulldozer promotes Shell, a remnant from the gas station immediately to the west.

Construction of the Hittie family business by D & D Scarborough of Stewartstown continued through the winter of 1988–1989. The grand opening of the facility occurred on May 13, 1989. Several expansions have been made to the True Value Plus Home Center in recent years, nearly doubling its original size.

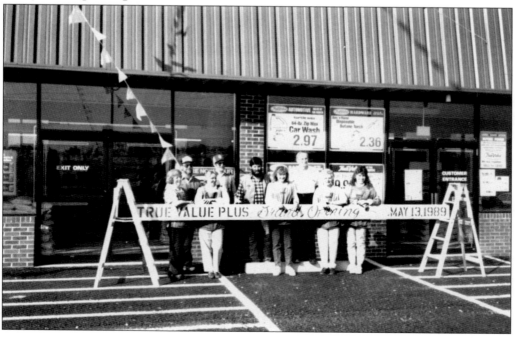

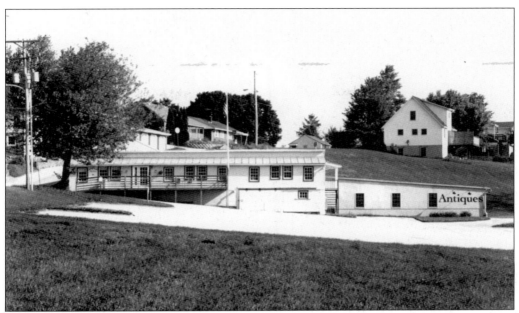

Antique stores and period shops occupy much of Shrewsbury's Historic District today. The co-operative antique center shown above, located on the east side of North Highland Drive behind the Factory, is the largest and oldest antique store in Shrewsbury. It was once the site of Norman Kehr's sewing factory. Sewing factories operated in Shrewsbury into the late 1970s. Commercial and residential development never end in Shrewsbury. Below, heavy equipment prepares the site for the building of a new Radio Shack in front of the MacDonald's in 2004.

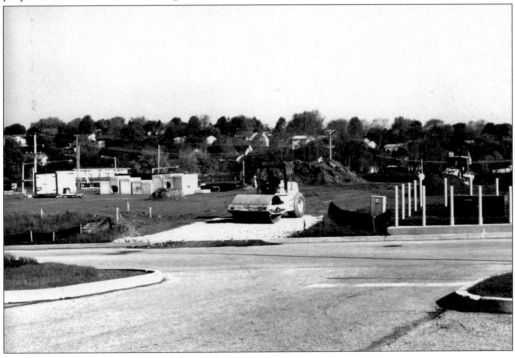

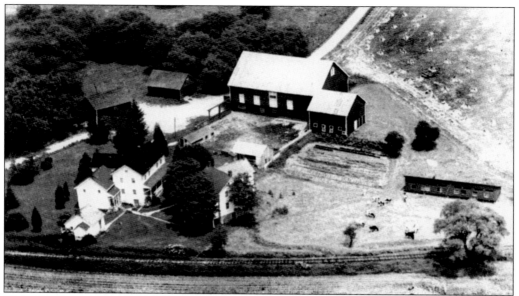

This aerial view shows the Emanuel Keeny farm, located along the north side of East Tolna Road, east of Interstate 83. The dirt road that goes from the left and up would later be realigned, paved, and become Elm Road. The railroad tracks belong to the Stewartstown Railroad. None of theses buildings are still standing. Today, this site is the wooded area across East Tolna Road from the industrial park.

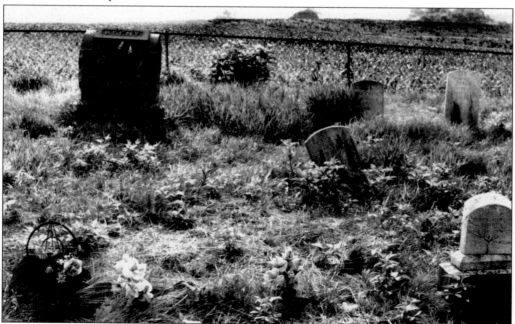

A small Keeny family cemetery occupies the farm field a short distance to the northwest of the Emanuel Keeny farm. The cemetery can easily be seen on the east side of Interstate 83, just north of East Tolna Road. Until recently, a large tree grew inside the small fenced-in area, drawing the attention of northbound travelers.

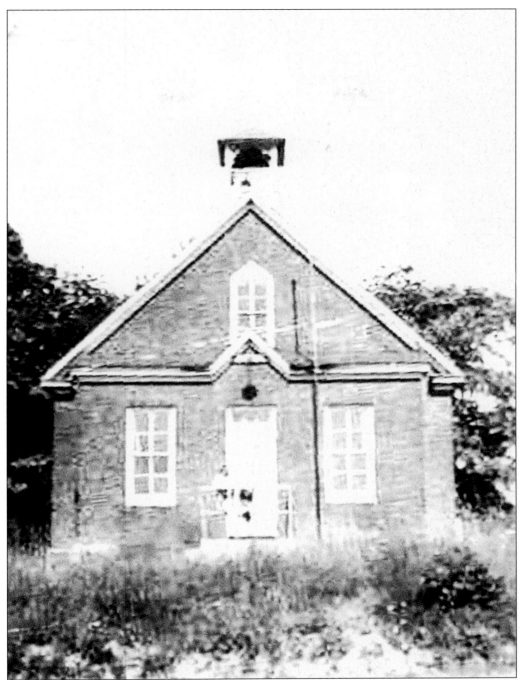

This late-1800s photograph depicts the Keeny School on Windy Hill Road. The previous wooden schoolhouse had been destroyed by fire in the 1890s. It was replaced in 1897 by a brick schoolhouse at the same location, which is now a private residence. Shrewsbury Township and the surrounding area boasted 13 small schoolhouses; 11 of them exist today, mostly converted into residences.

After a three-year interruption, work began in 2004 to reconnect South Highland Drive to Mount Airy Road (formerly Church Road). The addition of more housing units, along with the need for alternate access to the elementary school, made reopening the roadway a necessity. The above photograph looks west from the traffic circle on Mount Airy Road. The view below looks north from the same location. The roadway is yet to be graded and paved. This land will see additional units of the Presidential Heights development.

Shrewsbury Elementary School opened in 1998 in response to the expected increase in elementary-age children because of the town's rapid growth. The elementary school on West Railroad Avenue had previously closed, and the classes were moved to the Southern School District campus near Glen Rock in 1972. The expansion of the community can be realized by comparing the sizes of the two elementary schools.

Looking southwest from the traffic circle on Mount Airy Road across the fields at the back of the new elementary school, one can see part of the retirement village at Shrewsbury Courtyard. For many years, this part of Mount Airy Road (then Church Road), north of East Tolna Road to the present traffic circle, was a dirt road that provided a convenient shortcut to East Forrest Avenue via South Highland Drive. The road was not improved until the Presidential Heights development had begun.

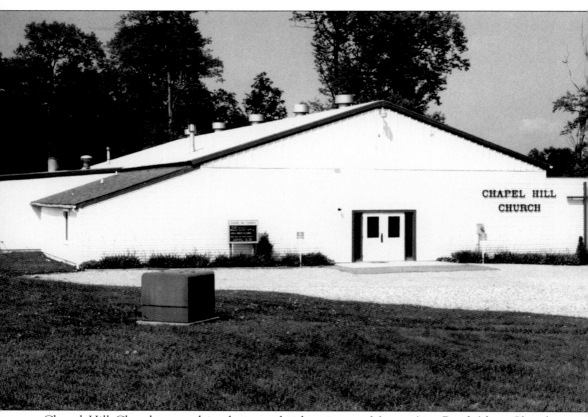

Chapel Hill Church opened its doors at this location on Mount Airy Road (then Church Road), south of East Tolna Road, in the late 1980s. Before becoming a church, this building was a foundry that produced brass boat propellers and, for a short time, was a machine shop. Today, it is also used as one of the polling locations in Shrewsbury Township.

Five

WEST OF THE SQUARE

When Shrewsbury Borough was incorporated in 1834, it purchased this hand-drawn cart for fire fighting. The cart, built in 1780, was given the name Dart. To get pressure to project water, the handle on each side had to be pumped. The Dart was rescued when the engine house burned to the ground in 1880 but was destroyed in the mid-1930s, when the barn in which it was stored burned.

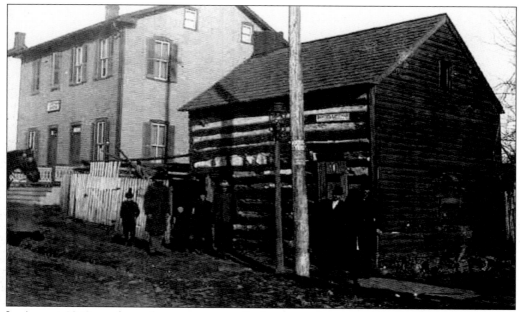

In August 1948, work was begun on a new firehouse on the northwest corner of West Forrest Avenue and North Sunset Drive. This photograph shows the site in the late 1800s, when a bakery occupied the corner. The firehouse that was built here replaced the 1880 firehouse that still stands a few doors east on West Forrest Avenue.

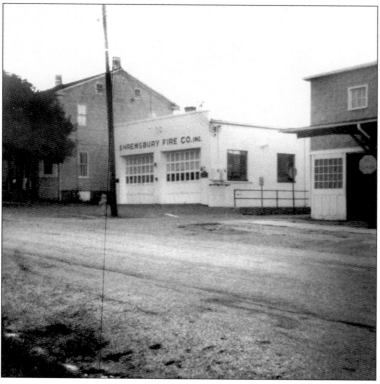

The new firehouse was dedicated in June 1949. In August 1949, fourteen-year-old Harold Shaffer discovered a fire at the new firehouse while riding his bike. Shaffer sounded the alarm, and the flames were soon extinguished. Starting in the restrooms, the fire caused about $1,000 damage. This firehouse was then destroyed by an explosion and fire on September 27, 1972. The damage totaled $250,000, including the loss of all the fire company's vehicles and equipment.

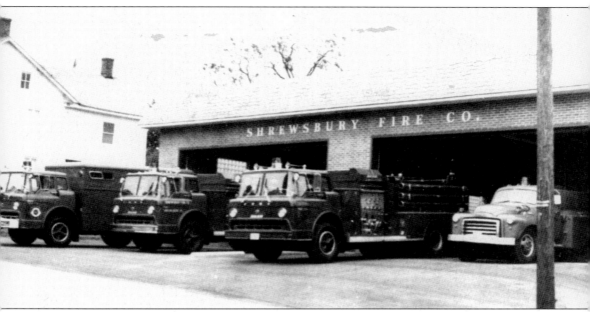

The fire on September 27, 1972, not only destroyed the station but also damaged the house next door so badly that it had to be razed. That left enough room for this larger firehouse to be built onto the front of the social hall that had survived the fire. This station still serves the community and the surrounding area today. The social hall is used for many functions, including bingo, craft shows, and the annual flower show.

The Shrewsbury Furniture Factory was a multi-building facility located on the southwest corner of West Railroad Avenue and South Sunset Drive. The furniture parts were manufactured on the first floor of the two-story building, and the parts were assembled on the second floor. The assembled furniture was then taken to another building for finishing. These two photographs show all that is left of the Shrewsbury Furniture Factory.

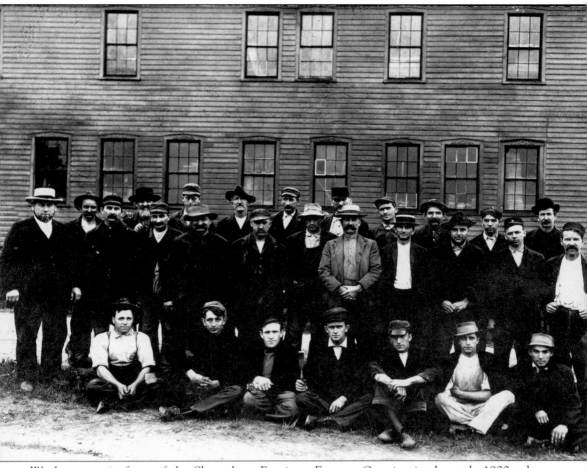

Workers pose in front of the Shrewsbury Furniture Factory. Opening in the early 1900s, the factory produced quality furniture that was shipped all along the East Coast and as far west as Chicago. It finally closed its doors during the Depression. In addition to this factory, local funeral directors also made furniture as a sideline to their casket-making and undertaking business.

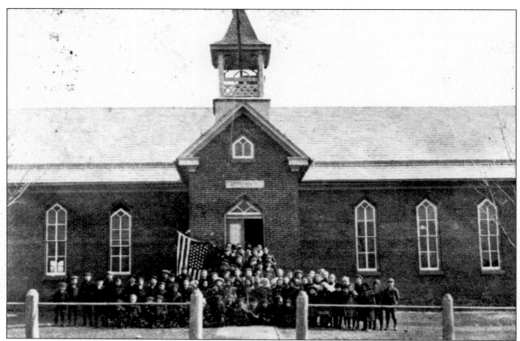

The Shrewsbury Public School stood across the street from the Shrewsbury Furniture Factory, on the north side of West Railroad Avenue. Built at least 13 years before the furniture factory, the public school was a replacement for the old school on the east side of North Main Street. The new school served grades 1 through 10. In the above photograph, the flag on the east side of the building bears 45 stars, indicating a date between 1896 and 1907. The below photograph was taken from the east side of the school in 1946, showing the addition of another classroom.

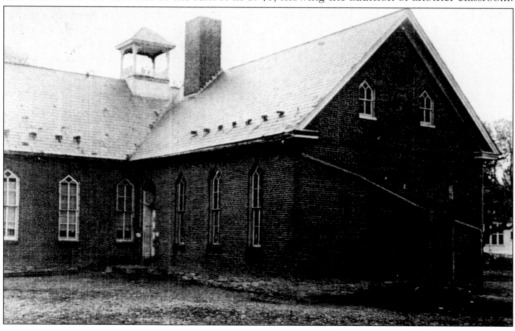

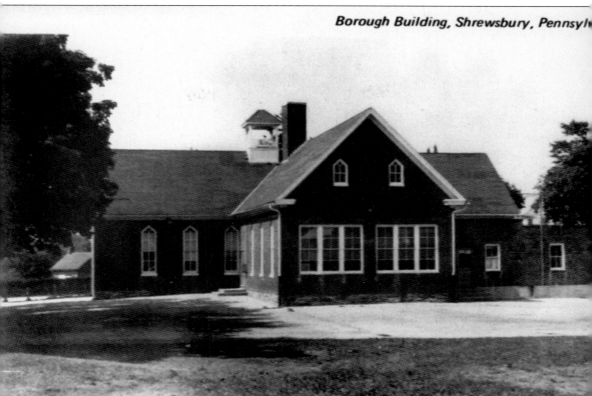

In 1952, an addition expanded the northeast side of the Shrewsbury Public School, providing enough space for a kitchen to be installed. Beginning in 1952, the school provided education for grades one through five. After the public school closed in 1972, Shrewsbury elementary students were transported to the Southern School District campus near Glen Rock. In 1973, this school was deeded to the borough. Since that time, it has served as the Shrewsbury Borough Building. This photograph was taken from the location of the borough garage, erected in 1976.

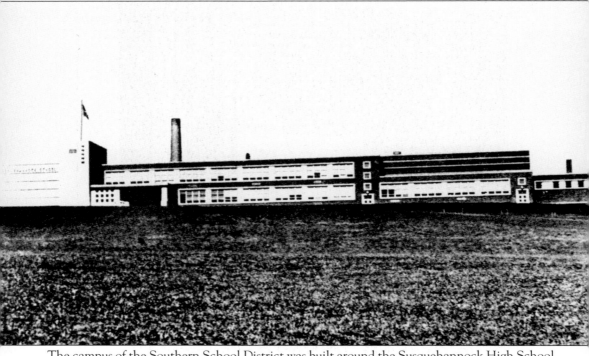

The campus of the Southern School District was built around the Susquehannock High School, which opened in 1951. The first graduating high school class was in 1952. In future years, an elementary school and a middle school were added. Shrewsbury would not see another local school until the Shrewsbury Elementary School opened east of South Main Street in 1998.

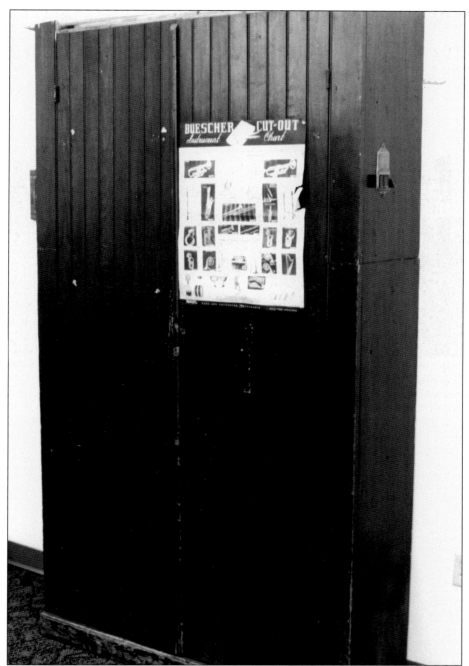

This cabinet is an original piece from the Shrewsbury Public School. It was donated back to the borough by the daughters of W. Carl Scott. Scott taught school for about 20 years and was Shrewsbury Borough secretary for 22 years before retiring in 1974. The cabinet is now used in the borough office, where an accompanying plaque details the donation. The chart on the right door shows an assortment of musical instruments. The device on the right side of the cabinet is a broom holder.

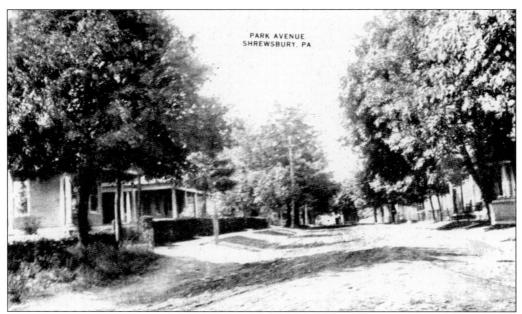

PARK AVENUE
SHREWSBURY, PA

One of the shortest streets in Shrewsbury is Park Avenue, running from West Walnut south across West Forrest to West Railroad Avenue. On the west side of Park Avenue, at the intersection with West Forrest, stands the Shrewsbury Gospel Temple. On the lot on the south side of the church is the old Masonic Lodge building, which today is owned by the church and used as a fellowship hall. The photographs above and below were both taken from in front of the Shrewsbury Public School (now the borough building). The houses shown on both sides of Park Avenue are still standing.

The Shrewsbury Gospel Temple stands on the site where the first log church was built in 1821. After the log church was destroyed by a tornado in 1840, this church was built on the same site in 1853. Older residents still refer to it as Albright's Church. For nine years, the Assembly of God occupied the church, until it built a new building on the west side of North Main Street.

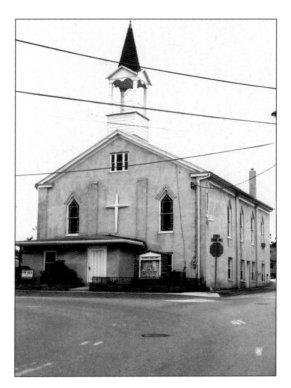

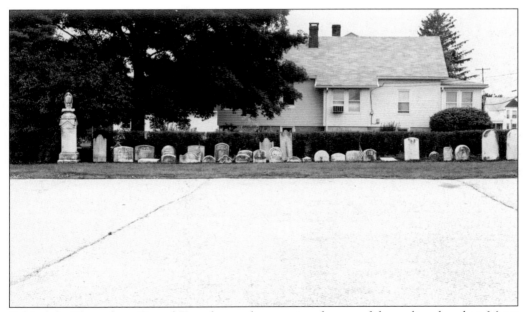

Behind the Shrewsbury Gospel Temple was the cemetery for one of the earlier churches. Many years ago, long before the church became the Gospel Temple, the headstones were moved to the western end of the property and an asphalt parking lot was installed. The headstones still rest in their relocated positions.

After the Freemasons outgrew the room they used on the third floor of the Jackson House on the northeast corner of the Square, they built this Park Avenue lodge hall in the late 1800s. They continued to use this lodge until 1977, when they moved to their new brick facility on East Forrest Avenue. The Shrewsbury Academy (high school) also used this building from 1910 to 1920, and the Shrewsbury Gospel Tabernacle bought it in 1977.

The old Seibel's Cider Press was located along the west side of South Sunset Drive, near the present fire station. The picture to the right shows the building in its early days, when it housed the cider press. The building, still standing today, was renovated many years ago into apartments, as seen below. In the 1980s, it housed Jeffrey Hostetter's stringed instrument repair shop. This is another example of an old building that can be seen only from the back streets of Shrewsbury.

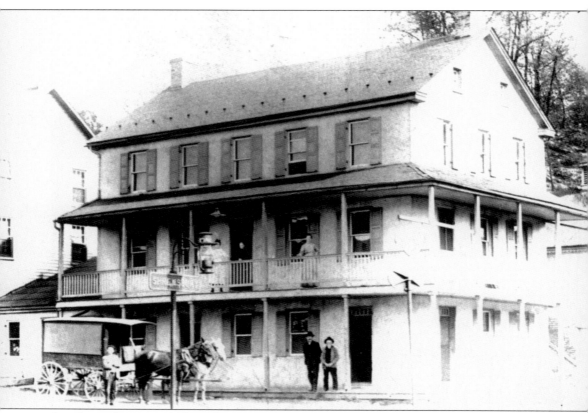

A mile to the west of Shrewsbury is Railroad Borough. Before Railroad was incorporated in 1871, it was known as Shrewsbury Station. This 1859 photograph of the Jackson House was taken from the north side of what is now Main Street in Railroad, near where the train station was located. The site of the train station was the present parking lot for the Heritage Trail. The sign on the lamppost is an indication to passengers that they have arrived near Shrewsbury.

Six

AROUND TOWN

This photograph of Charles Ehrhart was taken in front of the home that stood on the southeast corner of East Forrest Avenue and South Highland Drive. Ehrhart sold and traded horses from his stable on the northwest corner of East Forrest and North Highland. Several livery stables were located along East Forrest Avenue in the 1800s, including the one that stood behind the Shrewsbury Hotel. Ehrhart's stable was razed in 1914, and the house pictured here was also razed in 2003.

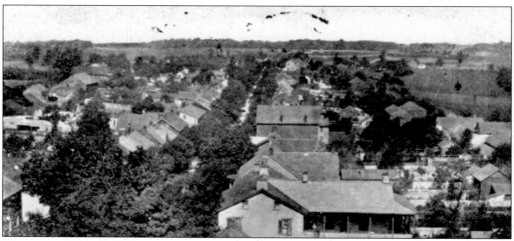

From a card postmarked in June 1907, this bird's-eye view of Shrewsbury looks north from the steeple of the Lutheran church on South Main Street. The Shrewsbury Hotel, with its large porch, appears in the lower part of the photograph. Gerry's Drug Store is in the lower left corner. Barely visible at the top, to the right of center and below the tree line, is the Shrewsbury racetrack.

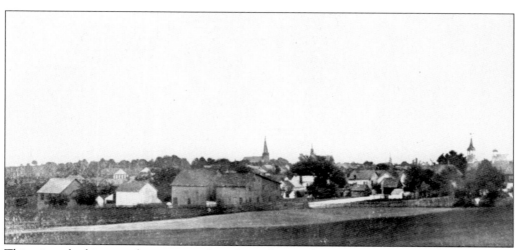

This view, looking southeast, was taken from the northwest quadrant of town. The tallest steeple, appearing in the center, is the Lutheran church. The next steeple to the right is the Methodist church. Further to the right is the steeple of Solomon's Reformed Church (now St. Paul's United Church of Christ). The top floor of the Odd Fellows Hall can be seen just above the small white building to the left.

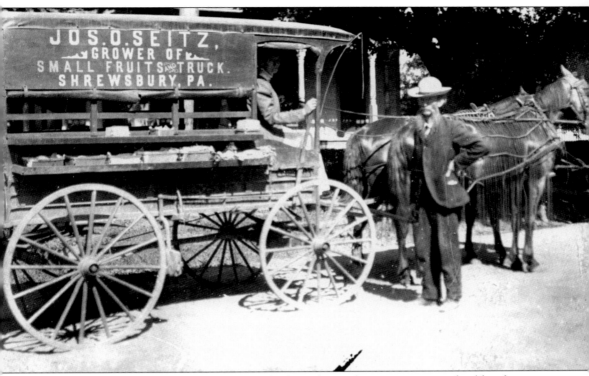

Joseph Seitz was one of the many farmers who brought produce into town and sold it from a wagon along the curbs. In an era before home refrigerators and freezers, farmers who operated this type of truck farming business would make trips into town several times a week. Like the local neighborhood stores, this type of commerce slowly faded from the streets of Shrewsbury. Note the odd stringy covering draped over the horse's back.

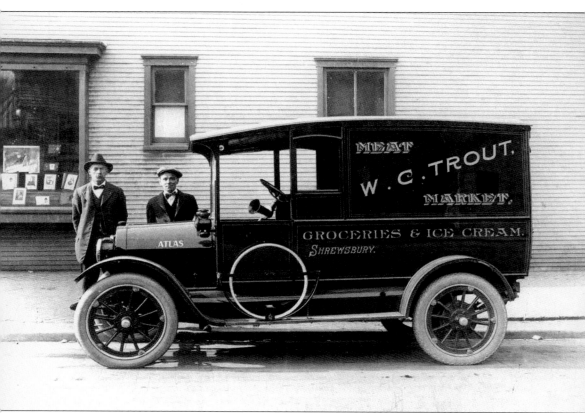

Similar to the horse-drawn wagons and carts of the earlier truck farms, mechanical trucks were also used to bring goods into town and to make local deliveries. W. C. Trout operated this Atlas truck as part of his meat market at 23 South Main Street. This photograph was not taken in Shrewsbury but more likely in Glen Rock.

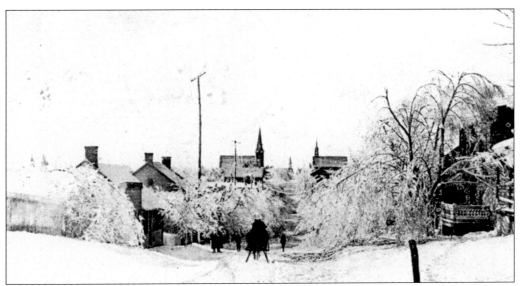

This scene, likely from the winter of 1905–1906, was printed on a postcard dated 1906. It was taken on North Main Street at about Playground Avenue, looking south. The steeple to the left is the Lutheran church, the one in the middle is the Reformed Church (now Church of Christ), and the steeple to the right is the Methodist church. The damage to the trees indicates that the storm was a combination of snow and ice. The height of the utility poles above the houses is curious.

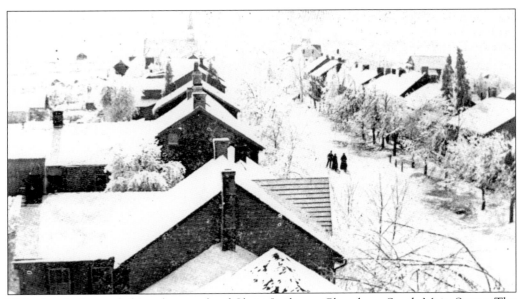

This view looks south from the steeple of Christ Lutheran Church on South Main Street. The Reformed Church appears in the distance. The damage to the trees is not as apparent from this height, but some smaller branches are visibly bent and broken on the right.

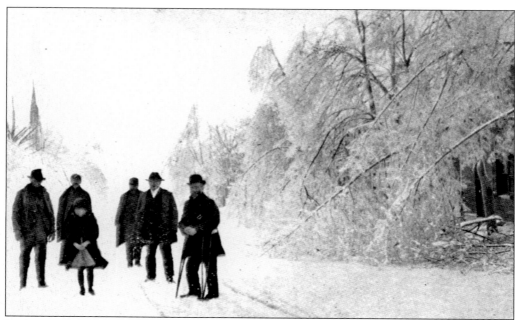

In this southward view of South Main Street at street level, the effects of the weight of the snow and ice are apparent. The overcast sky indicates that the storm may still be going on or has just ended. The gentleman to the right appears to have already had an encounter with an icy street or sidewalk, hence the crutches.

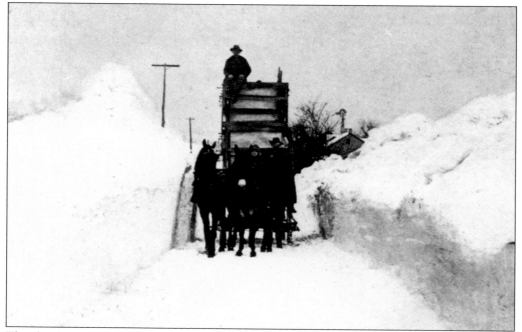

The depth of the snowfall is easily seen in this view along Park Avenue. The sides of the snowbanks show that the street was shoveled by hand and not by snow-removal equipment. Snow of that depth would take months to melt and most likely contribute to some local flooding.

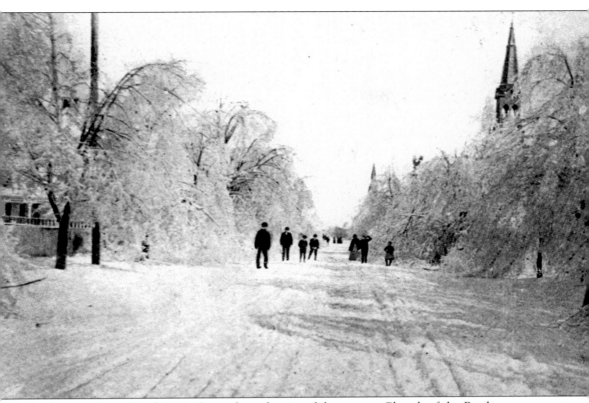

Looking north on South Main Street from the site of the present Church of the Brethren, one can seen that nearly every tree has suffered some damage. The number of people gathered in the street, though, indicates that the worst conditions have passed. The tracks in the street reveal that people were able to get around by horse-drawn carts and wagons. The sanctuary on the right is the Reformed Church, and the steeple barely visible in the distance is the Christ Lutheran Church.

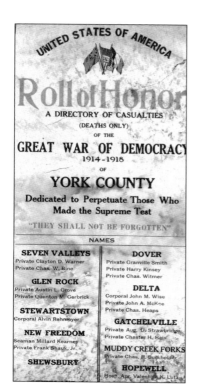

The roll of honor to the left was printed in memory of the York County residents who lost their lives during World War I. As it shows, no one from "Shewsbury" lost his life during the war. Below, a parade is held on Main Street to honor the local veterans of World War I. As a lasting tribute to the Great War veterans of York County, sycamore trees were planted along the Susquehanna Trail. Over the years, many of the trees were lost due to ice and windstorms. Encroachment into power lines has required the surviving sycamores to be radically cut back. Many can still be seen on the south side of town.

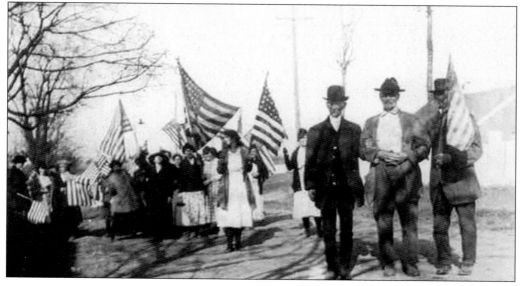

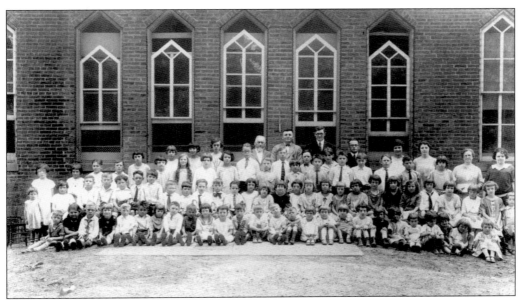

The Shrewsbury Public School was also used by the town churches for the combined Vacation Bible School. This photograph of the 1925 Bible school class was taken on the west side of the building. Of course, the building was not air-conditioned at that time, so the windows had to be opened for ventilation. The middle four windows have chicken wire over them, and the other windows have larger wire fencing to keep the birds out.

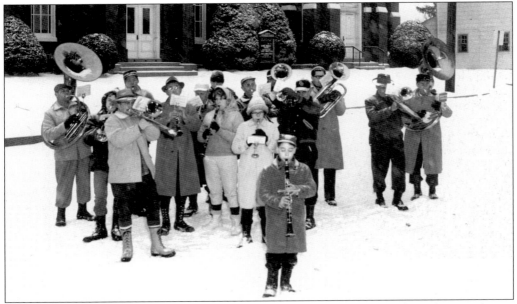

For years, bands would walk the streets and play Christmas music in a Shrewsbury tradition. Organized bands in Shrewsbury can be traced back to the mid-1800s. This 1962 holiday photograph was taken on South Main Street in front of Christ Lutheran Church. The young boy standing in front playing the clarinet is Steve Saubel.

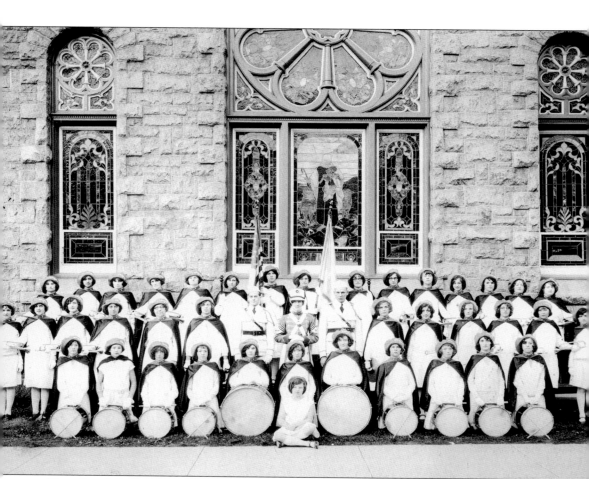

The all-girl Shrewsbury Trumpet and Drum Corps was the first of its kind in the country. The corps, made up of girls from Shrewsbury and the surrounding communities, participated in parades and area picnics, and performed at the ribbon cutting for the Wrightsville-Columbia Bridge on Veterans Day in 1930. Pictured here, from left to right, are the following: (center front) Evelyn Ayres; (first row) Bertha Royston, Lila Rehmeyer, Julia Burns, Belva Kimes, Viola Wagner, Martha Wagner, Ellen Triplett, Alice Gale, Beulah Burns, Mabel Miedwig, and Florence Baum; (second row) Hazel Ayres, Hilda Smith, Helen Diehl, Alma Blouse, Irene Smith, Gladys Bollinger, Britton Koller, Florence Gale, William Diffendall, Hazel Cox, Tressie Osborne, Pauline Royston, Sara Kline, Erma Cox, and Doris Ayres; (third row) Maud Hildebrand, Odessa Blouse, Alice Hildebrand, Ida Wilhelm, Myrtle Stover, Rhelda Smeltzer, Mabel Gale, Thelma Heiss, Edna McClain, Dorothy Rehmeyer, Mary Gale, Ruth Baum, Mabel Wilhelm, Grace McWilliams, and Ruth McWilliams.

This type fan was a common form of advertising in the early 1900s used by a variety of businesses, including small stores, markets, churches, and funeral homes. The picture side of the fan would show an image corresponding with the advertising on the opposite side. Churches and funeral homes usually used a picture of flowers or Jesus. In this case, the advertisement is for a small neighborhood store that sold baby food.

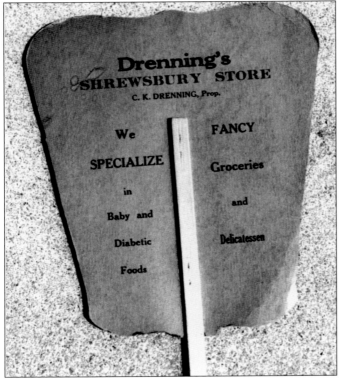

The opposite side of the fan was where the commercial business could present its message to the customer, or a church could present a scripture or its name and location. Drenning's was a small neighborhood store that operated from 136 North Main Street. Such stores began to fade in the 1960s, when larger full-service supermarkets came to town.

This small telescopic plastic water cup was a popular glove compartment item in the 1940s and 1950s. It could hold about four ounces of water and was convenient for taking aspirin, which could be carried in a compartment in the cup's lid. This particular cup was an advertising item for Smith Brothers Sunoco on North Main Street. The actual date is unknown, but the cup was produced when the trail was still designated as U.S. Route 111 and before telephone numbers had three-digit prefixes.

This protective registration card holder was another advertising giveaway that became popular in the 1980s. This particular holder is from Choice Auto Center on East Forrest Avenue. Choice was a multi-bay garage and service station selling Citgo gasoline into the 1980s. The location was once the site of small shops in the early 1800s, as well as the Shrewsbury Hotel, Frank Sechrist's Garage, Warren Mitzell's Garage, Aero Oil Company, McCullough's Exxon, and Choice Discount Cigarettes and Exxon. This corner has seen many changes.

To the right, then patrolman Chris Geary stands beside a newly acquired 1975 Plymouth Grand Fury police car. Shrewsbury Borough maintained a small police department until January 1, 1992, when it joined New Freedom to form the Southern Regional Police Department. Glen Rock then joined the regional department in 1998. Geary is now a sergeant with the Southern Regional Police Department. The shoulder patch below was worn on the Shrewsbury Borough Police uniforms until 1992. Many borough and township departments, as well as the state police, used this basic keystone design at one time or another. Some jurisdictions still do.

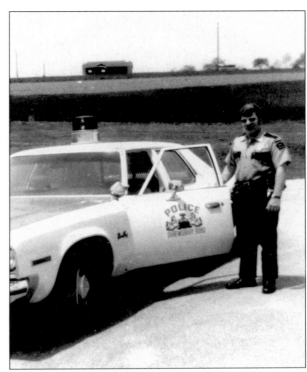

The Shrewsbury Fire Company can trace its roots back to the town's incorporation in 1834. At that time, fire protection was the responsibility of the borough, and in 1876, a committee was appointed to serve the purpose. When the fire company was organized and chartered in 1933, the borough was no longer responsible for fire protection. Not immune to fire itself, the Shrewsbury Fire Company station has been the victim of destructive flames at least four times in its history.

This commemorative plate was issued for the rededication of the current fire station. The station was originally dedicated in 1949. In September 1972, however, flames destroyed the front portion of the building, which housed all of the town's firefighting equipment. The burned section was replaced with a larger facility that was built onto the front of the social hall. The new fire station was rededicated on June 8, 1974.

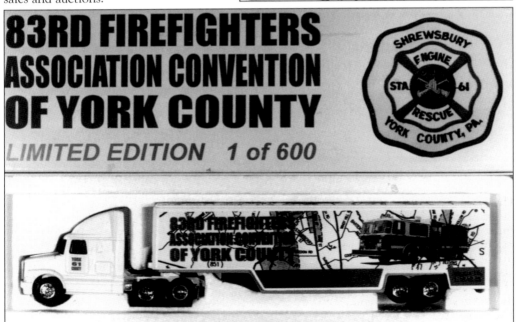

The Shrewsbury Fire Company hosted the 83rd Firefighters Association Convention of York County on August 19, 1995. To mark the occasion, Matchbox issued the Rescue 61 truck on the right and Ertl issued the collector's Shrewsbury Fire Company truck tractor semitrailer below. Both of these collectibles are scarce today and are considered to be great finds at yard sales and auctions.

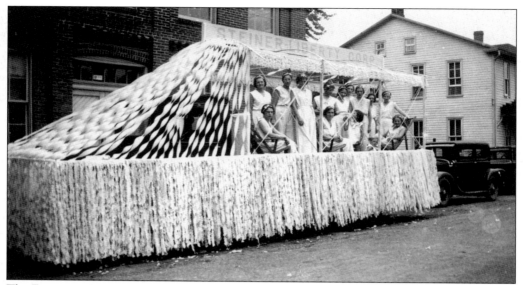

The Firemen's Carnival and Parade is an annual event in Shrewsbury, drawing marching bands and units from the neighboring communities and counties of Pennsylvania and Maryland. Above is Steiner-Liberty's float from the 1930s, shown in front of the company's sewing factory. The float below is from the 1950 parade, when Grace Methodist Church was celebrating its 100th year. The judging stand for the parade was located in front of the church because of its location at the top of the hill on South Main Street.

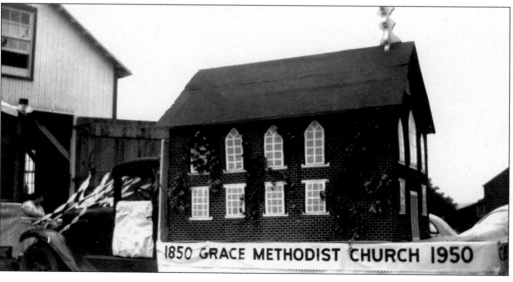

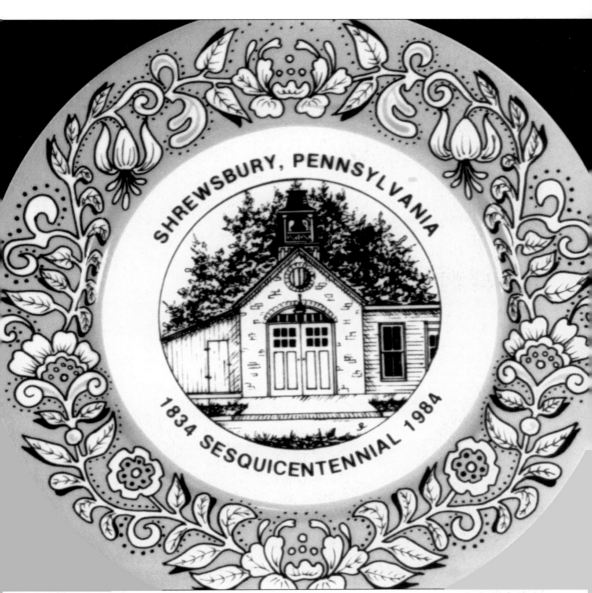

This souvenir plate was sold with an accompanying mug as a sesquicentennial souvenir set. Other items sold were stock certificates, wooden nickels, and miniature tea sets. The sesquicentennial logo was designed by Jim Richardson, who also coordinated the Shrewsbury history book that was published in commemoration of the town's 150th year.

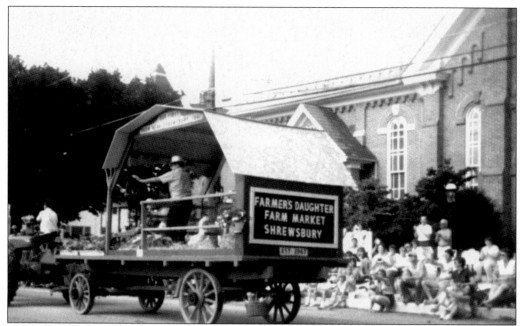

Shrewsbury celebrated its 150th birthday in 1984. The celebration began on Sunday, August 5, and ran through Saturday, August 11, with activities planned for every day of the week. Activities were conducted at the Shrewsbury Playground, Thompson's Potato Farm, and the Shrewsbury Fire Hall. The sesquicentennial parade was held on August 11. Above, the float entered by Farmer's Daughter Farm Market passes Christ Lutheran Church on South Main Street. Below, the Sesquicentennial Queen, Grace Wise (left), and the Sesquicentennial Princess, Kim Swingler (right), wave to the crowd as the parade proceeds north.

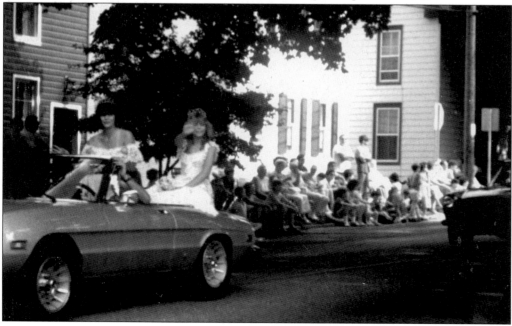

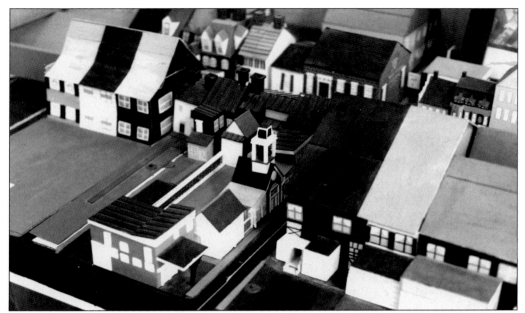

This cardboard model of Shrewsbury's Historic District was constructed by Matthew Kelly, Caleb Rohrbaugh, Matthew Wagner, Michael Williams, and Jimmy Yashur as a Webelo Scouts project. The model is kept on display at the Shrewsbury Borough Building. Shrewsbury's Historic District is bordered by Sunset Drive and Park Avenue on the west, Pine Avenue on the north, Highland Avenue on the east, and Church Avenue on the south. The Historic District was entered into the National Register of Historic Places in 1984 by the U.S. Department of the Interior.

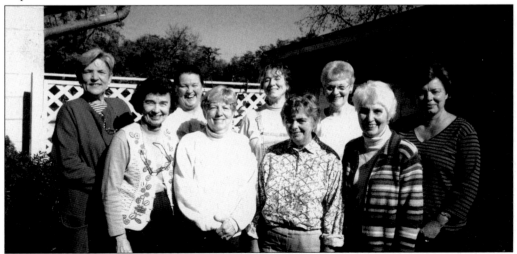

The Shrewsbury Flower Show has been a nearly annual event for the past 54 years at the town fire hall. The show was begun by the Ladies Auxiliary of the Shrewsbury Fire Company and was not held for two years because of drought conditions. Members of the 2003 Flower Committee are, from left to right, as follows: (first row) Sherrill Trimpey, Gardenia Wallace, Doris Shaffer, and Sarah Richardson; (second row) Lida Thompson, Dee Adel, Carol Bailey, Sharon Hartenstein, and Sue Anne Clumbsky.

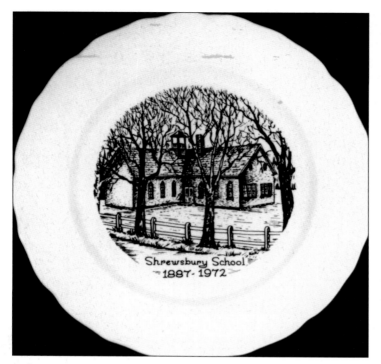

This commemorative plate depicts the Shrewsbury Public School building, which served the community's children from 1887 until 1972. It continues to serve the community as the Shrewsbury Borough Building on West Railroad Avenue. Extensively renovated, it contains many photographs and artifacts from "Old Shrewsbury," which can be viewed by the public.

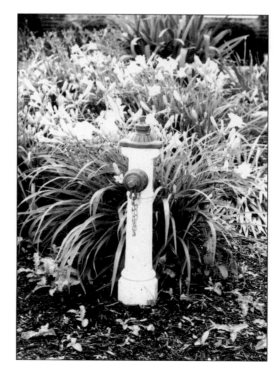

This Old Shrewsbury fire hydrant, located on the east side of South Main Street, was struck by a car in 2001 and broken off its base. The borough public works department removed the hydrant and base from the curbside and had them cleaned and welded back together. This cleaned, repaired, and repainted hydrant is now in the garden at the Shrewsbury Borough Building. It is likely the only one from Old Shrewsbury still in existence. The date of its original installation is unknown.

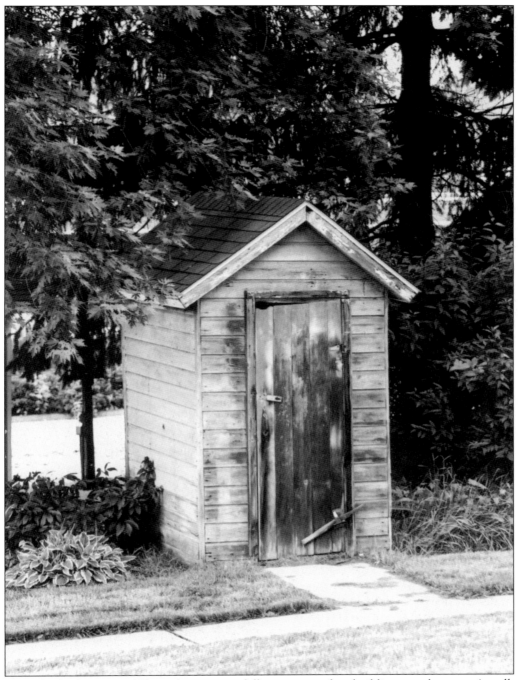

From the back streets of Shrewsbury, many different types of outbuildings can be seen. A walk along Highland Drive, Sunset Drive, Park Avenue, and any of the east–west avenues will reveal a glimpse of Old Shrewsbury from more than 100 years ago. This outbuilding is just one of many that have been preserved and well maintained. Others are in need of attention to ensure their future.

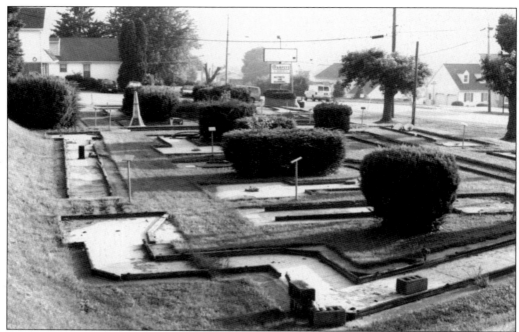

Shrewsbury's only 18-hole golf course was this now abandoned miniature course, located on the west side of North Main Street in front of Carpets by Martin. When it was in operation, the course featured a revolving clown, a pendulum, and an operating Eiffel Tower. The course was closed in 1988 because of escalating insurance costs.

Nearly all of the area that surrounds original Shrewsbury was, at one time or another, farmland. To define the boundaries of their land, farmers used stones that were unearthed during plowing to build fences. Few reminders of these fences still exist. This stone fence is located on Cardinal Drive between the Krout and the Brookview Meadow developments. It divided the McCleary farm to the north and the Foster farm to the south. Today, it divides the yards of newer homes.

To the northeast of Shrewsbury, near Grace United Methodist Church, is Nancy and Tim Swingler's Joy Garden. The Joy Garden consists of a perennial garden, a rose garden, a four-seasons garden, a fountain, and a conservatory. The conservatory, shown here, is a small glass building set in the garden where people can find a peaceful place to meditate and socialize over tea.

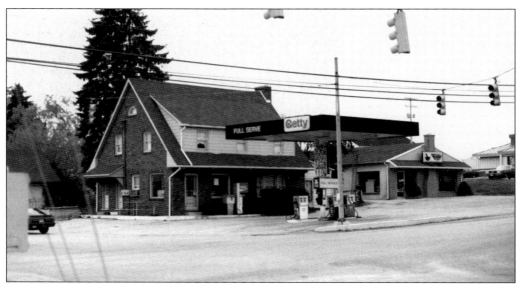

Jim Thacker, and later Fred Ritzmann, operated a service station on the northwest corner of South Main Street and Constitution Avenue. Ritzmann also operated a lawn mower and chainsaw business in the building that later housed the Medicine Shoppe. On the southwest corner of the intersection, where the Getty Mart is today, Paul "Thumper" King ran a service station. Also on that corner was a restaurant called Dot's Diner, which was a popular trucker's stop before Interstate 83 opened.

Market Square Shopping Center was built in 1974. This 1994 view shows it before renovations. The store on the extreme left was first occupied by McCrory's, then Newberry's, and now D. E. Jones. Book Peddler owned two storefronts that are now occupied by 1st Preference and the Gift Shoppe. The supermarket in Market Square was first Safeway and then Valu-Foods. The drugstore has been used by Coover's, Epco, Thrift, and Eckerd.

Looking north over the Southern Farms area, this aerial view was taken in 1974. The bare area at the middle left is the site of Market Square Shopping Center. The S-shaped street running north and south is Brandywine Drive and Winchester Road. Crosswinds Drive has only been partially completed. Some of the homes along Magnolia Circle (now Strassburg Circle) and Covington Drive have not yet been built. Fieldstone and Westbrooke Circles are the streets in the lower portion.

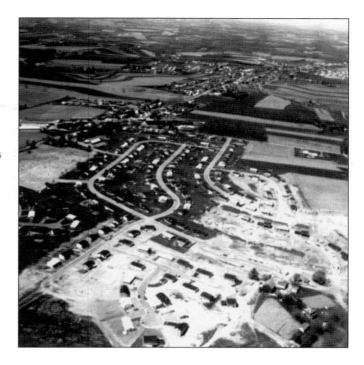

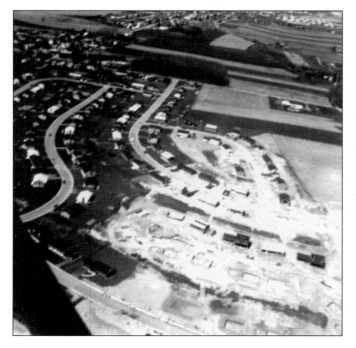

This view of the same general location reveals open fields that are now the site of the Shrewsbury Elementary School, the Presidential Heights development, and the former K-Mart–Giant shopping center along East Forrest Avenue. Southern Farms was the first major housing development on the south end of town. It was started in the late 1960s in the area outlined by Virginia Avenue and Essex Circle. The section along Covington and Crosswinds Drives was completed in the mid-1970s.

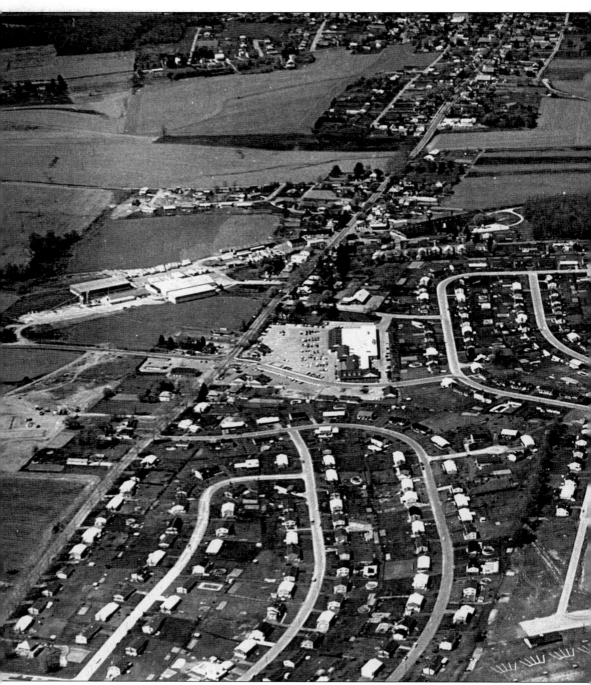

Several interesting observations can be made when looking at this late-1970s view from the south. The ground has been cleared, and building has just begun at the Lutheran Retirement Home. Nothing has yet been constructed between Pizza Hut and the offices of the former Hungerford Packing Company. Onion Boulevard has not been extended beyond the packing company buildings. There are open fields to the east of South Main Street, where the

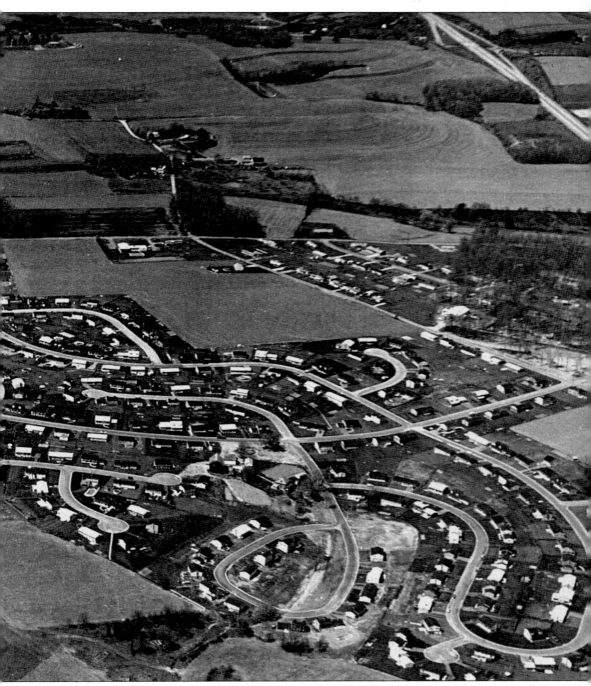

Shrewsbury Elementary School is today. Some parts of Church Road (now Mount Airy Road) and South Highland Drive are dirt and have farmhouses on them. These were removed before the road was realigned. More open fields occupy the space where the K-mart–Giant shopping center, Shrewsbury Commons, and Presidential Heights will soon be built. Construction has just begun on the townhouses along Eastwood Drive.

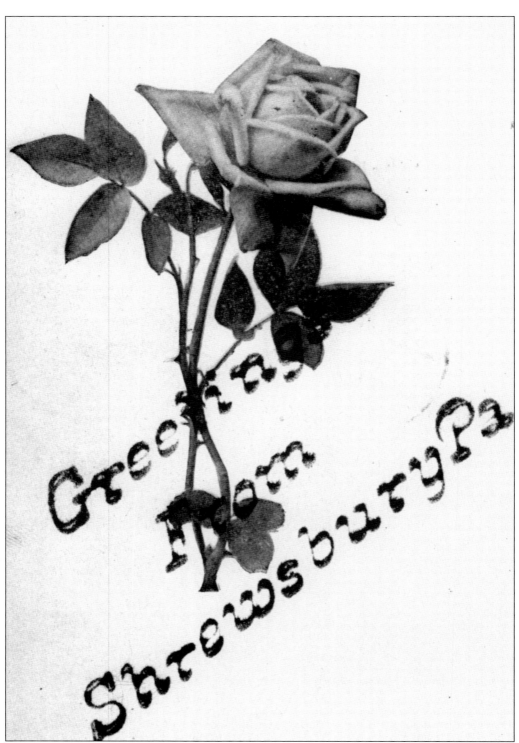

Shrewsbury, Pennsylvania, offers a closing greeting.